WITHDRAWN

S0-AHY-534

HOLOCAUST HEROES: FIERCE FEMALES

TAPESTRIES AND SCULPTURE BY LINDA STEIN

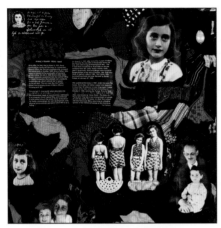

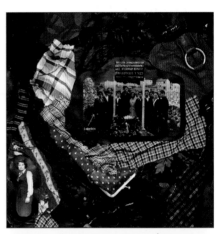

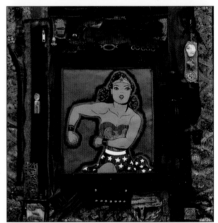

OLD CITY PUBLISHING

Yeshiva University Museum
15 West 16th Street
New York NY 10011

HAVE ART: WILL TRAVEL! INC.

BOARD OF DIRECTORS

Linda Stein

Helen Hardacre

Susan Schweitzer

HONORARY BOARD

Loreen Arbus

Abigail Disney

Lauren Embrey

Merle Hoffman

Carol Jenkins

Patti Kenner

Ruby Lerner

Pat Mitchell

Ellen Poss

Elizabeth Sackler

Gloria Steinem

HAWT ADVISORY COUNCIL

Sue Ginsburg: Chair

Mary Blake

Beth Bolander

Jerome Chanes

Sarah Connors

Marilyn Falik

Eva Fogelman

Karen Keifer-Boyd

John McCue

Jeanie Rosensaft

Menachem Rosensaft

Amy Stone

Published in 2016 by Old City Publishing, Inc., 628 North Second Street, Philadelphia, PA 19123

Book copyright © 2016 by Have Art: Will Travel! Inc.
Artwork copyright © 2016 by Linda Stein, all rights reserved
Individual authors hold copyright to their essays

Book design and production by Drew Stevens, studiodrew.nyc
Photography by D. James Dee, Jeffrey Scott French, and Stein Studios
Amy Stone, Line Editor · Ann Holt, Copy Editor

ISBN 978-1-933153-30-8 (paperback) · 978-1-933153-32-2 (hardcover) · 978-1-933153-31-5 (ebook)

Contents

Preface and Acknowledgments

MY JOURNEY BACK to the time of the Holocaust is ongoing. It has changed me in ways I cannot now fully appreciate. I feel, within my body, a shift, a visceral tugging that is new to me. I am more empathetic. I cry more easily. I ponder daily acts of generosity and self-sacrifice more deeply. I stare intently at images of Hitler and other perpetrators. I seek out exemplars, and long to learn of the souls of our collective past.

For now, many of my thoughts and feelings cannot be sewn together into a tapestry of words, but my hope is that my exhibitions, lectures, educational initiatives and workshops will facilitate the telling of this story. My delight in helping people realize that their own push past being a bystander, during an everyday situation of bullying or harassment, is an act of courage and bravery. Admittedly, I may never have the backbone of each of the ten female Holocaust heroes I choose to highlight in this book. Yet, for the first time in my life, I feel it a privilege when I have the opportunity to be an upstander as I go about my daily routine.

There are many people to thank for supporting this endeavor. My wife, Dr. Helen Hardacre, has remained at my side through this journey. Albeit quietly turning to me on occasion to express her need to take a break from watching Holocaust movies, she continues to see many of them with me, along with exhibitions and events, and to listen to, contribute to, and be affected by my reactions to the history I am internalizing. My gratitude, along with my love and admiration, belongs to Helen.

Though my mother and father have long past, I extend my deep love to my family, wholeheartedly supportive of me as I have weaved through my personal and professional transformations. I want to thank, in particular, my sister Carole Siemens, my brother-in-law Richard Siemens, and my niece Rebecca Siemens Spooner.

Friends and colleagues have had considerable input in the progress of this book, especially Joyce Froot, friend and champion for almost fifty years; Merle Hoffman, long-time trusted ally and brainstormer; Susanna Ginsburg, child of a Holocaust survivor, and Chair of the Advisory Council for Have Art: Will Travel! (HAWT), giving generously of her time and expertise; Dr. Ann Holt, art educator and Executive Director of HAWT, who has worked insightfully and tirelessly on the production of this book as copy editor, as well as on HAWT's programs and workshops; Dr. Karen Keifer-Boyd, professor of art education and Women's Gender and Sexuality Studies at Penn State University, who has been key to the inauguration of the Linda Stein Art Education Collection at Penn State University; Rochelle Saidel, director of Remember the Women, whose writing with Dr. Sonja Hedgepeth inspired me to include the spoon as a metaphor in my art.

I am grateful to Dr. Ian Mellanby of Old City Publishing, who has trusted in my work over the years, and confirmed his support as publisher of this book; Amy Stone, our astute line editor and advisor; Drew Stevens, our talented book designer; the team at Cleary Gottlieb Steen & Hamilton LLP, especially Daniel Ilan, Jane Rosen and Lilia Stantcheva, who have provided inestimable legal expertise; Henry Galarza, our ingenious construction manager at Stein Studios for almost two decades. Amongst others providing highly valued insight and encouragement are Loreen Arbus; Camille Barbone; Marnie Berk; Dr. Alison Bernstein; Beth Bolander; Judith Brodsky; Annette Danto; Beverly Dash: Abigail Disney; Lauren Embrey; Marilyn Falik; Lois and Marc Freedman; Lisa Hetfield; Carol Jenkins; Annelie Koller; Raymond Learsy; Ruby Lerner; Debra Lobel: Elena Mancini; Dr. Joan Marter; John McCue; Katharine McQuarrie; Pat Mitchell; Dr. Ferris Olin; Ellen Poss; Achebe Powell: Jeanie Rosensaft; Dr. Elizabeth Sackler; Susan Schweitzer; Stacy Lauren Smith; Robin Snow; and Dr. Lori Sokol.

The Memorial Foundation for Jewish Culture has helped fund the preparation of this book,

along with HAWT's many individual donors; Sarah Connors has been the judicious producer of our short video on *Holocaust Heroes: Fierce Females*, with Lily Henderson, the film's discerning director and editor. Sarah and Pam Hogan are in the process of making a three-part TV documentary about our Holocaust project. My gallerist and friend since 2005, Eleanor Flomenhaft, an author and respected curator, could not have been more enthusiastic and supportive of my art over the years. She is the rare art dealer who chooses to emphasize, through her gallery exhibitions, the value of women in a male-dominated art world. In our many conversations over the years, we have discussed how the female artist, even today, may still be seen as the *other*.

Though not a visual artist, Gloria Steinem comprehends this bias toward the *other*, as she exudes empathy and understanding. With fondness and gratitude, I think of the time she spent at my Tribeca loft, talking about issues of bullying and bigotry, with openness and generosity of spirit. Her contribution to the feminist mission of *equality for all* continues to be significant, and I am delighted that she has written the foreword for this book.

Following the Steinem foreword is an introduction by Eva Fogelman to the ten heroes. Dr. Fogelman's 1994 *Conscience and Courage: Rescuers of Jews During the Holocaust*, was one of the books that most impressed me in my early readings of the Holocaust. Her passion for helping Holocaust-impacted individuals, the main part of her New York therapy practice, is infectious, and her zeal to identify types of rescuers and share their stories, was inspirational to me. A child of Holocaust survivors, she speaks out continuously on behalf of victims, emphasizing how important it is to recognize and reverse bullying behavior at very early stages. She has been an ardent and generous supporter of this book and all HAWT projects.

I extend my heartfelt gratitude to the authors of the ten hero essays, who expertly synthesize the valor of their subjects. From around the world, they join together in presenting the courage and compassion of these Jews and non-Jews who are worthy of a prominent position in history: David Barnouw from Amsterdam, Michael Kovner and Dalia Ofer from Israel, Shrabani Basu from London, Kathryn J. Atwood from Chicago, Dr. Carol Rittner from Pennsylvania, Dr. Molly Merryman from Ohio, Marge Piercy from Massachusetts, Patti Kenner and Menachem Rosensaft from New York.

Dr. Gail Levin holds a special place at the very beginning of my journey into the time of the Holocaust. A respected art historian, teacher and author, Dr. Levin has been in my life since 1999 when she selected my sculpture, *Soft Curve 312* (fig. 29), for an award at Guild Hall Museum in East Hampton, New York. She had no prior information about me, not even my gender, when she gave me that honor. Through the years, over dinner and on other occasions, we became friends, and shared professional as well as personal experiences. In one 2008 discussion, we talked about Judaism, and she suggested I do a Jewish-related art series. Though I was not ready to do this at the time, the idea hit a chord within me, and floated around in my head for three more years. It was not until I saw the 2011 New York Times obituary about Nancy Wake, that this vague rumination began to take shape. Fascinated by Wake's story, I started researching everything available about her in books, essays and films. Indeed, it was Gail Levin who planted the seeds for my exploration.

This book would not be complete without its final collaborative essay by HAWT's Curriculum Team of scholars, headed by Dr. Karen Keifer-Boyd, and including Dr. Cheri Ehrlich, Dr. Ann Holt, Dr. Wanda Knight, Dr. Yen-ju Lin, Dr. Adetty Pérez de Miles and Leslie Sotomayor. Together they have developed an annual *Holocaust Heroes: Fierce Females Summer Teaching Institute* highlighting strategies on how to engage students or self-learners in identity, justice, and leadership encounters with my art.

Nothing has excited me more than hearing a fourth-grader explain what it takes to be a hero, watching a college student perform a dance addressing the continuum between masculinity and femininity, or listening to an adult recite a poem, or enact a skit, on bullying and bravery. It is with art as a starting point that I take what I have absorbed from the time of the Holocaust and bring it into the public arena.

—*Linda Stein*
New York City, 2016

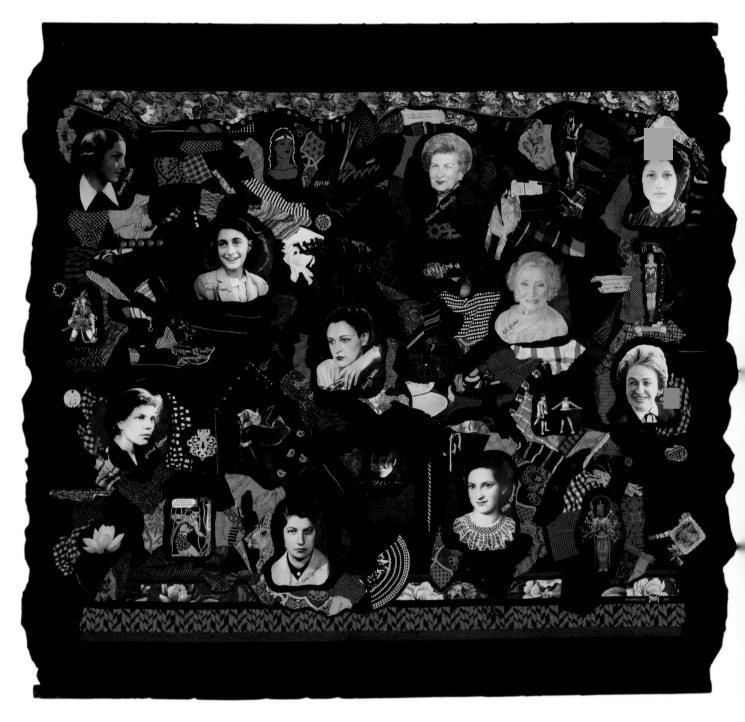

FIG. 1. *Ten Heroes 859*. Leather, archival pigment on canvas, fabric, metal, zippers; 56 x 61 x 2 inches; 2016.

Ten Heroes 859

Included in this tapestry are the ten Holocaust heroes chosen by Linda Stein, as well as the artist's pantheon of pop-culture and religious icons of protection. The blending of fantasy and reality figures are meant to start a conversation addressing what it means to be an *everyday hero* and brave *upstander* against bullying and bigotry.

Thoughts on Viewing Holocaust Heroes: Fierce Females – Tapestries and Sculpture by Linda Stein

Gloria Steinem

Linda Stein's studio is a magical place. The moment you enter, you see female figures that are larger than life. As a woman, you feel you can take up more space than you did before. You see female bodies that are clothed in mythological symbols. You feel as if you might be a part of myth and history.

This change in feeling is a hint of the power of her *Holocaust Heroes: Fierce Females,* a new exhibit that is part of her ongoing educational program through the non-profit, Have Art: Will Travel! Inc. In this special work, she is helping to restore the reality of women's lives and actions during the Holocaust.

Instead of being presented only as victims and bystanders, those who were acted upon, women are seen here as full human beings who made a difference. In many earlier histories, for instance, female experience, even as victims, has been expurgated. Not until 2010 were Sonja Hedgepeth and Rochelle Saidel able to publish *Sexual Violence Against Jewish Women During the Holocaust,* a collection of testimonies to a sexual violence that had died with its victims, or had been silenced by shaming those who survived. Just as the story of war in the former Yugoslavia or the Congo would not be complete without recording the violence directed at females, the history of the Holocaust must not be told without it.

That is the true and negative story. This is also a true and positive one. The story of the Holocaust must include the many brave Jewish male heroes *and* the many brave Jewish female heroes.

Because Linda Stein's work symbolizes, expands upon and makes visible a world of female bravery, our witnessing of her work – seeing her images and learning the stories of the women she portrays – can invite our own bravery. We do what we *see* far more than what we are *told.* Bravery simply means turning our capacity for empathy into action. The human species could not have survived without our need to help another human in trouble. When you and I see someone in need, we are flooded with oxytocin, the hormone known as the tend-and-befriend hormone, the one that floods both men and women when we hold a baby. Yes, it can be inhibited or overcome by an early history of trauma and abuse that convinces us we have only two choices – to be the victim or the victimizer – but this inhibition comes from nurture, not nature. If we have been lucky enough to be raised without trauma or to recover from it, we

FIG. 2. Gloria Steinem (right) wearing a Linda Stein sculpture. New York, 2015.

retain the ability to empathize with each other, to help each other, to become fierce in the cause of protection, nurturing, justice, kindness.

This instinct to share, to be concerned about human beings near us, has been observed even in infants.

Growing up, I remember seeing mysterious newspaper photographs of police dragging black people through the streets of nearby Detroit. My mother explained to me that black Americans – Negroes as then was said – had been enslaved, and that to justify this, an idea had been invented that Negroes were inferior. Our family lived through the Depression, but other families were still having to demonstrate in the street for food, shelter, jobs. I was more aware of racism than of the Holocaust on another continent, yet I did know that my Jewish paternal grandmother had used the remains of her money as a widow to ransom Jews out of Germany and into Israel. Then my mother let me listen to a radio drama about a mother trying to care for her child in a place called a concentration camp. In both cases, I knew she was sharing stories not to frighten me, but to include me in something serious and grown up. I had endless rescue fantasies about helping that mother and child, or driving up in my father's car and rescuing people in the Detroit photographs. Even at a distance, this impulse to help another human being is within us.

Later, I began to identify with the person experiencing unfairness. This was not a conscious decision, but an instinct. The good news about being human is that we're adaptable; therefore the species survives. The bad news about being human is that we're adaptable; therefore violence and unfairness can be normalized and make us fearful that helping a victim will make us a victim, too. Yet, unless we have been too traumatized by violence or shame or humiliation, there is always an ability inside each of us to identify with others. That's why the human race survives.

This is also why seeing Linda Stein's empowering images of women – and learning their stories of using their power – can help to release the power within each of us. It's true that dominance, aggression and control have been normalized as "masculine" – and submission, passivity and obedience have been normalized as "feminine" – in order to allow male-dominant systems to control females and therefore reproduction. But the basic reality is that we are all human. In the matrilineal societies of the past – for instance, in many Native American societies on this continent, as well as the Kwei and the San in Africa or the Dalits in India, it was the circle, not the pyramid, that was the organizing principle of life. This may be coming true again in the future. Women's movements around the world are working toward a shared humanity and balance that comes with reproductive freedom, equal education and equal power in governance. Within all of us, female and male, there is an instinct for equality that makes children of the world say some version of, "It's not fair," and, "You are not the boss of me."

Stein's art intentionally blurs the polarized prisons of gender stereotypes – prisons that punish and endanger men as well as women – by depicting androgyny, a shared and powerful humanity. It is reflected in the worldwide truth that our images and our hopes are changing. Our ideas of the possible are changing. Though we have been told that this change only comes from the top, the truth is that change is like a tree that grows from the bottom. The smallest act of kindness may have unpredictable results.

Linda Stein wants us to relate these Holocaust heroes to everyday, mundane acts of compassion and bravery. The art of creating positive change is behaving. We must behave as if everything we do matters – because it might. ■

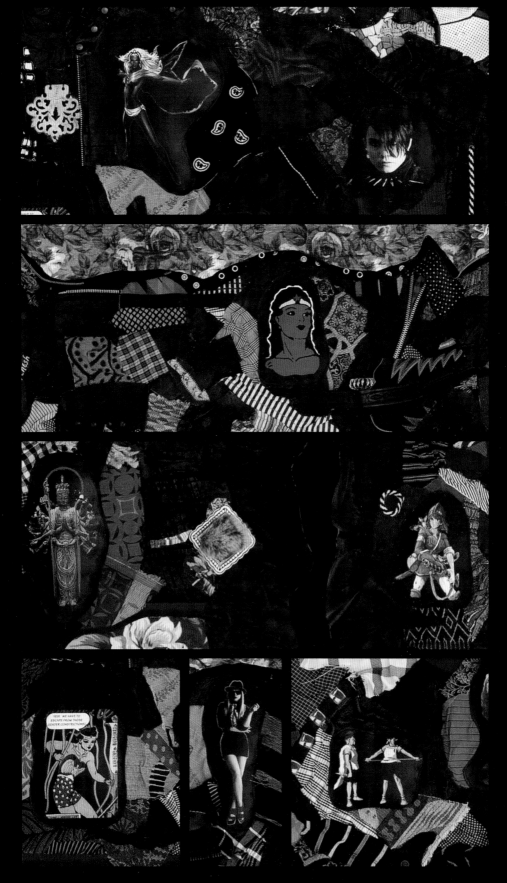

FIG. 3. Details from *Ten Heroes*, 859.

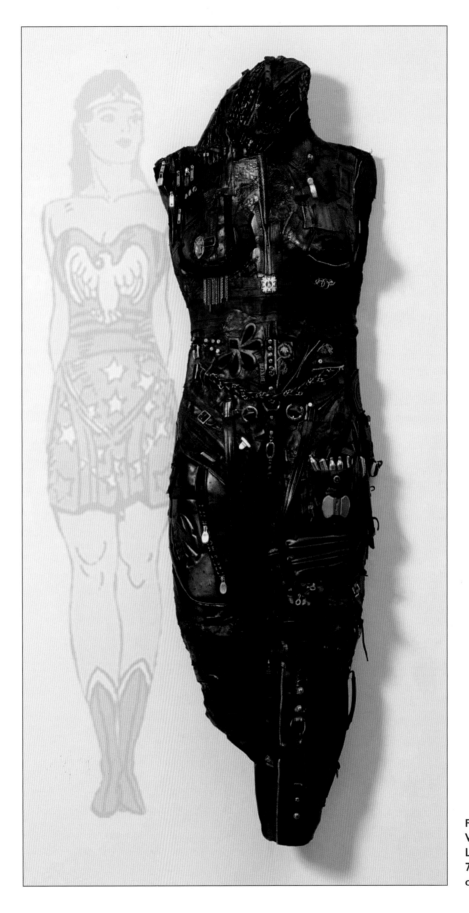

FIG. 4. *Protector 841* with Wonder Woman shadow. Leather, metal, mixed media; 78 x 24 x 8 inches (*Protector* only); 2014.

The Protector and Exemplar

Linda Stein

It's three o'clock in the morning. You are awakened by a knock on the door. A person in rags, looking close to death, pleads *Let me in your house. Please. They will kill me unless you hide me.*

Quick, what do you do? You know that if you say *Yes*, and the authorities find out, you run the risk that not only you, but your spouse, parents, children and the rest of your family and friends will be murdered.

Most people close the door and say *No* – but some, a few, open it and let the person in. These are the rescuers who protect the vulnerable, giving thought to neither their own safety nor bravery, hardly considering themselves heroes at all. These are the ones who would say years later, *I could have done nothing else. It was the only humane thing to do.*

Often, in the comfort of my home or studio, or on a quiet outing, I think, as many might, of the role I would have played in this setting. Would I be the rescuer, the brave upstander? Or would I be the bystander, the onlooker who notices victimization, but then goes about my day concentrating on my myriad mundane concerns? I'm not sure. Can any of us, except those who have faced it, be sure?

Consider another situation: Now imagine yourself kept captive in a prison where you are tortured and treated so despicably that the simple, everyday spoon becomes a vital tool of survival. It is valued especially because it helps you avoid putting your lips to the tuberculosis-infested urn containing a watery gruel being passed around in lieu of food. Hardly anyone around you has a spoon and you desperately want one. Suddenly, someone comes up to you and presents you with a box. You open it and inside there is a spoon. You express heartfelt gratitude. But slowly it becomes clear that this gift will be given only in return for sexual favors. What then? Do you accept the spoon?[1]

To survive under such mental and physical trauma, what kind of protective shell do you need to conjure up for yourself? How do you harden your face into a mask to hide the fear, anger and devastation welling up inside you?[2] How do you *will* your body into the shell of your former self, one that you hope will steel yourself from further personal atrocities? How, in these terrifying circumstances, do you keep your sanity and self-respect?

If you are fortunate, you will unlikely face such horrific scenarios in your lifetime. Your need for protection will, hopefully, not involve

life-threatening persecution and abuse; your confrontation with evil will not be with a genocidal terrorist. Even so, I would petition that you should not, cannot, must not, be a bystander when witnessing everyday persecution, whether it's psychological brutality, sexual abuse, ostracism, humiliation or any other kind of harassment. With or without life-and-death adversaries, you still have an opportunity to show your mettle through courage, compassion and empathy. You have a chance, almost every day, to stick-up for someone being put down by a bully, someone excluded or slandered by a bigot.[3] As I see it, you can take on one of four roles in this scenario. I call them the 4B's: Bully, Bullied, Bystander, Brave Upstander. Possibly, in your lifetime, you have personified more than one of these roles, at one time or another, when confronted with oppression.[4]

Art as Activism

Tackling oppression – including racism, sexism, classism, ableism, homophobia – through the lens of bullying and gender justice, is the mission that has guided me as activist and artist in the making of my tapestries and sculpture for *Holocaust Heroes: Fierce Females*. This is the inspiration leading to my creating *Heroic Tapestries* after choosing ten people who represent different aspects of bravery during the time of the Holocaust: Jew and non-Jew, child and adult, World War II military fighter and ghetto/concentration camp smuggler, record keeper and saboteur. Together they represent the many types of heroism exhibited, with war battle gear and without, during the years of the Holocaust.[5] And they are female.

Men, as protectors, have received far more attention than women. With these tapestries, I seek a corrective to this history, and highlight ten women who have been courageous during this period, and I visually address some of the issues they faced. For my *Spoon to Shell* box sculptures (figs. 5 and 16), inspiration came from reading about sexual abuse during the years of 1933–1945, the twelve years of Hitler's power.[6] The simple, everyday spoon – as valuable as gold in the concentration camp – became a metaphor for me in thinking about the victim's continuous trauma. Shocked and grieved, I beheld how its intended function as a tool for sustaining life, a vessel for feeding, had been perverted into an instrument of evil intent and cruel power over the vulnerable. Correspondingly, the shell, nature's housing of protection, as I see it, also became a metaphor for me, as a mask and defensive covering one had to wear in order to survive. I could not get images of the spoon and shell from my mind. They haunted me. I finally had to physically gather as many of them as I could obtain, in order to express my visual and visceral response to the heinous and grotesque crimes committed during the time of the Holocaust.

What force could I evoke to stand in as the counter to this egregious evil? What symbol could I summon to represent the antithesis of the genocidal oppressor? The answer came to me in the heroic countenance of my *Protector* sculpture (fig. 4). Larger than life, this fantasy form was roused from the depths of my fears, from my deep-rooted feelings of vulnerability,[7] and soon became my concept of fierceness-and-strength-incarnate. With its skin of black leather, blend of zippers, badges, buckles and mixed-media, it morphed into my surrogate for the brave defender who brings security and safety. It is not a figure actively looking for battle;

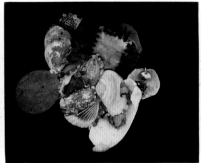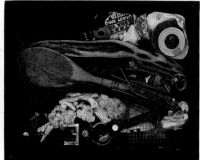

FIG. 5. *Spoon to Shell* (left to right) *823, 832, 837.* Spoon, shell, and mixed media; 11 x 14 x 2 inches; 2015.

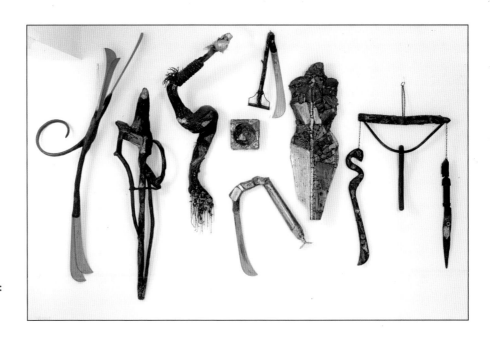

FIG. 6. Wall installation from three different series: *Ceremonial Scepters, Blades, Knights.*

it is a sentinel, watching and waiting, on-the-ready to protect the persecuted. As a sculptural archetype, it combines the androgyny that I believe all humans share; it is as much masculine as it is feminine.[8]

Such is an overview of the personal coded mapping for my project. It took hold of me by surprise. Never a religious Jew, I always felt pride in my heritage, albeit not in an established religion that demanded deference from females to males. This project became an opportunity for me to revisit my Jewish ties through feminist eyes, to cherish my background and tradition without becoming religious; I remain a secular Jew.[9]

A Feminist Journey from the Abstract to the Figurative

My quest for justice and equality (the words, very simply, I would use to define feminism), and my hunger to become exposed to new psychological terrain, provide the spur for me to meet and learn about *others* who are different from me. This exploration has continuously led me on unpredictable paths, reflected in my previous art series, including: *Scepters* in the 1980s; *Blades* in the 1990s; and then *Knights of Protection* (fig. 6) and *The Fluidity of Gender* after 9/11.[10]

I was primarily an abstract artist during the years before running from the falling Twin Towers on one very sunny Tuesday. I abruptly put creating sculpture on hold. My return to three-dimensional art a year later addressed my unconscious need for safety and protection,[11] as vividly demonstrated in my childhood dreams, where I ran and ran from pursuers who would do me harm.[12] As each of my post-9/11 sculptures symbolized my concept of the champion for justice – and my work became more and more figurative – I was in touch with my feelings of vulnerability. I was exploring and reinforcing my own strength and power as a protector, as well as my desire to be there for those who are persecuted.

It follows, for me, that my obsession with this theme of *Persecution to Protection* would naturally progress to studying the years of the Holocaust. My research has resulted in far more questions than answers, including whether educators should address bullying as being on a continuum. We see that micro-aggressions, starting out as unintentional slights at the expense of others, sometimes can develop into monstrous harassment and abuse. But is it counterproductive to instill young people with thoughts that their everyday bullying might lead to victimization on a macro level? I continue to read and reflect about this issue, and remain, as of now, still questioning.

Without question, we all – and young people, especially – need to have role models to admire

and respect. Providing inspiration, these moral exemplars help set our personal standards for what is decent and brave. But how do we choose them? Do we have to have a sense of morality first, before being able to make a selection? After so much reading and researching, I've made my best decision, and chosen nine women and one girl to represent exemplars of humaneness and bravery. My selection of females, rather than males, was very much in keeping with my feminist values and the gender-bending themes of my art, activism and life.[13]

Words Matter
Some have asked why I chose the word *fierce* in my exhibition title. They have adamantly said to me don't use it; it implies violence and killing. With my use of fierce, I don't focus on violence or killing. I define fierce as having intensity, being fervent, powerful, forceful, ardent, impassioned, fevered, strong – as in a fierce defender. I connect the word with a hunger for something, a desire to take action, do the right thing, stand up for an idea, right a wrong. Can we speak of Anne Frank as being fierce? I think we can. She was very brave as she went about her daily chores in the face of such brutality. At a young age she fiercely pursued her writing while in hiding. This fierceness grounded the influence her words had on so many. In fact, learning about her was my own introduction to World War II and the Holocaust.

I'd like also to address my selecting *hero*, not heroine, to describe each of these ten females. Understand, please, that a movie-clip goes on in my mind when I think of the word heroine, in which the fragile gal is tied to the railroad tracks, screaming for help, as the train is fast-approaching, only to be saved by the gallant lad who unties her, just in the nick of time! Our culture encourages us to think of the gal being saved as the heroine, the lad doing the saving as the hero. I could not let this stereotype stand for these ten brave females. They, indeed, are heroes.

My Selection of Icons and Superheroes
Travel back with me, if you will, to after 9/11, when I pondered my new sculptural creations. Gazing at these figures, they looked like armor to me, warrior-like and battle-ready (fig. 7). What was I doing? Aren't I still the pacifist who jogs around anthills? I found my new work puzzling. It remained troubling to me until one day, without warning, the thought of Wonder Woman came into my head, and I felt a sense of closure. *Yes,* I thought, *my work relates to her spirit, to Wonder Woman as a sentinel for peace, on guard to defend the weak.* I remembered, as a kid, buying her older used comic books, and went back and read every issue about her.

Wonder Woman has become a moral exemplar for me. For my current art I choose images from the first years of her creation (1941 until the death in 1947 of her creator, William Moulton Marston). I love that she is able to turn around the villains and help the downtrodden – by using her magic wrist bracelets, lasso and invisible plane – and without ever killing. She isn't perfect, I'll admit. Flaunted as a sex object, Marston played out his own sexual fantasies of bondage. Yet, I still feel Wonder Woman is the best of the female superheroes.[14] In my art, I re-create the graphics of her comics to reflect my own gender justice/anti-bullying proclivities. The comics of the 40s didn't show this superhero standing like

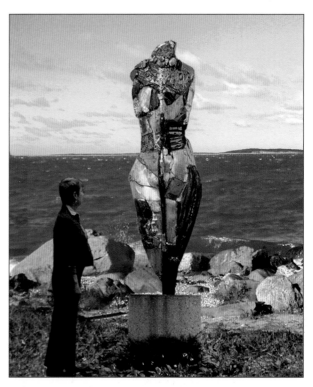

FIG. 7. *Knight of Tomorrow 582.* Bronze; 105 x 32 x 12 inches; 2005.

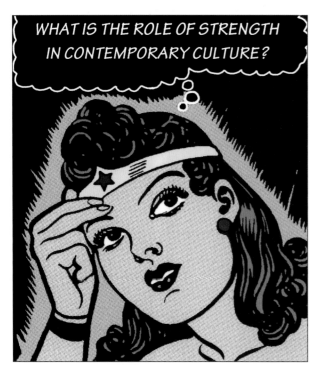

FIG. 8. Stein channels Wonder Woman and imagines her thoughts in today's world.

a sentinel with her arms straight at her side; I created her that way: standing at attention, ever on the lookout for trouble. I then used this new Wonder Woman stance as a "shadow" next to my *Protector* sculpture. I also changed her text-bubbles to reflect my own message: *Would you wear a bathing suit to get at the bad guys? What is the role of strength in contemporary culture? What defines bravery? What makes a hero?* (Fig. 8.)

There are other female superheroes and icons from religion and popular culture that inspire me and serve as role models (fig. 9).[15] Princess Mononoke, in the Japanese anime full-length feature film of the same name by Hayao Miyazaki, is a youth trying to save the environment from polluters.[16] She's brave and determined. Kannon, called by other names, including Guan-yin in China, is the Buddhist deity of mercy and protection, whom people turn to when seeking solace. Lisbeth Salander – the heroic protagonist played by Noomi Rapace in the Swedish movie version of Stieg Larsson's "The Girl with the Dragon Tattoo" – is a many-layered and excellent exemplar for discussions on violence and aggression in defense of the victim. Storm, a superhero of color (we need

more non-white superheroes) from X-Men comics, is known for the compassion she displays as she helps to rid the world of danger. Lady Gaga, though staunchly declaring she is no feminist, behaves like an ardent one in many ways. I also commend her for launching her anti-bullying foundation at Harvard University. And Nausicaa, in an anti-war anime by Miyazaki, is a protagonist who shows her commitment to love and understanding. She can calmly talk down an aggressive monster into quietly turning around and going home. Would that we had Nausicaa's ability, especially in today's world of perpetual war and hatred for the *other*.

There are, unfortunately, few female superheroes and icons that a feminist can embrace entirely. So many of them are sex-objectified and created with the male gaze in mind. As with everything else I do, I have selected those that can draw people into discussions of compassion and diversity, power and protection. For me, gender justice seems always to be at the heart of these issues.[17]

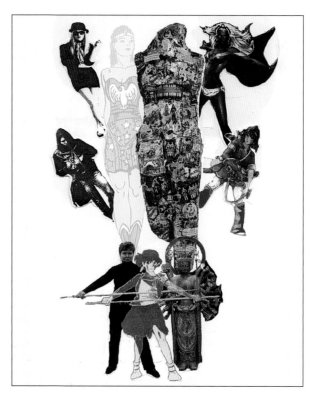

FIG. 9. *Standing with My Icons as Exemplars 216*. Limited edition fine art print; 24 x 18 inches; 2016. Clockwise from top left: Lady Gaga, *Justice for All 698* with Wonder Woman shadow, Storm, Nausicaa, Kannon, Princess Mononoke, Linda Stein.

FIG. 10. *Masculinities: Soft vs. Hard 860.* Leather, archival pigment on canvas, fabric, metal, zippers; 65 x 67 x 2 inches; 2016.

Have Art: Will Travel! Inc.

This is why I established Have Art: Will Travel! (HAWT), my non-profit corporation, which addresses issues including racism, sexism, ableism, classism, and homophobia.[18] It is the umbrella organization now facilitating my two current traveling exhibitions and educational initiatives: *Holocaust Heroes: Fierce Females* and *The Fluidity of Gender*. Other traveling exhibitions, including *Masculinities* (fig. 10) and *I Am the Environment* (fig. 11) are in progress.

HAWT's educational initiative includes an international team of scholars and educators planning curricular "encounters" with my art.[19] We work with all ages, either traveling to venues or inviting groups to come to our Tribeca loft in lower Manhattan to discuss bullying and bigotry, masculinity and femininity, persecution and protection. Summer 2016 marks HAWT's first annual Summer Teaching Institute, where international educators will come to Stein's studio to explore ways to incorporate *Holocaust Heroes: Fierce Females* into their curricula. These discussions, starting with art, inspire participants to reinvent and visualize

bravery for themselves: to look at the armor they wear, the protection they need, the safety they seek.

Components of *Holocaust Heroes: Fierce Females – Tapestries and Sculpture by Linda Stein*

My four-part exhibition includes (1) ten *Heroic Tapestries*, each highlighting a female hero during the time of the Holocaust, and referencing female superheroes, popular culture and religious icons that I chose when first creating *The Fluidity of Gender* series; (2) twenty *Spoon to Shell* box sculptures addressing victimization and masked self-effacement; (3) one larger-than-life *Protector* sculpture representing the fierceness and strength of the brave upstander and rescuer; and (4) a seven-minute looped video elucidating my art and activism.[20]

In working on my art, albeit the content and symbolism involved, I work as an abstract artist (fig 26). I first choose the images I expect to include in my *Heroic Tapestries*, such as a particular profile of Zivia Lubetkin, a passport

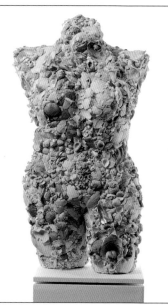

FIG. 11. Left: *Feathered Upstander 861*. Feathers, caste paper; 38 x 22 x 15 inches; 2016. Right: *Shell Homes 723*. Shells, caste paper; 37 x 21 x 12 inches; 2011.

Holocaust-related. Perhaps I am *occupying* my left-brain, while letting my right-brain take the lead in my art-making. This is especially true while creating the *Spoon to Shell* series, where I find myself working with shapes and forms, with little regard for content and narrative, much as I did in my abstract days prior to 9/11.

Conclusion

It is thrilling for me to see that my art, with its fantasy and real-life figures, can inspire people to begin a discussion about Gender Justice, Bullying and Bigotry. Magically, viscerally, empirically, art can help people experience new feelings and thoughts, leading to empathy for the *other*, the disdained *other*, the *other* that people don't want on their shores, in their work places, and certainly not in their homes.

for Nancy Wake, or a view of the house in which Anne Frank lived. Then I begin to combine these images into a whole, as one would combine shapes, colors and random bits of metals and fibers into an abstract composition. Aside from making some rules for myself (each *Heroic Tapestry* will be about five foot square, the left and right sides will be edged with black leather, the top and bottom will have a wide band of material; each box for the *Spoon to Shell* sculptures will be of flat black paint and 11 x 14 x 2 inches; each *Protector* sculpture will have one leg longer than the other and have a *skin* of black leather), I lose myself in listening to audiobooks, almost always

I like to think that we each have inside ourselves bravery, yet to be tapped. Courage and bravery doesn't mean the lack of fear, it means proceeding in spite of it. We each need to ask ourselves: *What would it take for me to be a Protector?*

Art can inspire us to become *Brave Upstanders* rather than bystanders. We just need to want this for ourselves, even in a small, everyday way. We need to be able to try on other avatars and choose moral exemplars to lead us to compassion and empathy. And, moreover, we have to be *fierce*. ∎

FIG. 12. Eleanor Roosevelt Center Girls Leadership Worldwide Workshop at Stein Studio, 2015.

Nancy Wake Dies at 98;
Proud Spy and Nazi Foe

Forgotten Female Holocaust Heroes

Eva Fogelman

After World War II, the recognized heroes were the brave warriors, the men in arms. The medals, the parades, the tributes were bestowed on the men (together with a few exceptional women) who fought on the frontlines or in the resistance. This reality set the stage for what became, in many countries, the collective memory of the war. The victims were shunned, and a small percentage of perpetrators were put on trial or underwent an often-bogus denazification program. As for the resisters, they were cognizant that their behavior helped defeat Hitler, but they were in mourning for many comrades who had been killed. At the same time, there were bystanders who claimed to be resisters, which created suspicion about the genuine resisters. For their part, the rescuers were living in fear of being "ousted" by their anti-Semitic neighbors as having been "Jew-lovers," and most did not want recognition for what, to them, was "the right thing to do." Diplomats who issued thousands of visas for Jews to escape Germany, Austria, Lithuania, and France lost their diplomatic status, their pensions, their honor. Some bystanders fabricated resistance stories or denied knowing that a genocide of Jews had taken place on their soil. Despite the Nazi war-crime trials, French historian Henry Rousso describes how there were "constant calls to forgive, to reconcile, even to forget the past," all of which "halted the mourning process."[1]

During this *zeitgeist* of exalting men in war, it is no surprise that female heroes were not taken seriously; indeed, the very words "female heroes" sounded like an oxymoron. This phenomenon, of denying the attributes of women as fierce, courageous, risk-takers in their altruistic and moral choices, was also noted in psychological research[2] contradicting other scholars.[3] Even forty years after liberation, a compilation of psychological literature[4] found that women were more likely than men to help, unless the situation was unusually dangerous. It was assumed that men had the skills necessary to undertake risky situations. Furthermore, men were considered more likely than women to help strangers because of their chivalry.[5]

Social psychologist Carol Gilligan, author of *In a Different Voice* (1982)[6] differentiated men and women in terms of morality. Gilligan claimed, when facing moral decisions, women do not think about what is right and wrong theoretically. Rather, they base their decision on feelings, compassion and care. On the other hand, Gilligan suggested that men's morality

is conditioned more by an impartial idea of justice than on an empathic response to human feelings.

These distinct differences between men and women were challenged by social psychologist Carol Tavris, who argued: "We can think about the influence of gender without resorting to false polarities."[7] This idea confirmed that of social psychologist Ervin Staub,[8] who himself was rescued in Budapest by Raoul Wallenberg.[9] Staub went so far as to develop measurements to identify people with altruistic natures. He concluded that both men and women have altruistic proclivities. While women are more socialized in early childhood to be compassionate and caring, men have those feelings as well, and are just as capable of acting on them. A further confirmation of not differentiating men and women when examining characteristics such as altruism and morality came from Freud himself. Freud explained that distinctions between men and women are not so clear cut. He wrote, "as a result of their [women's] bisexual disposition and of cross-inheritance, they combine in themselves both masculine and feminine characteristics so that pure masculinity and femininity remain theoretical constructions of uncertain content."[10]

In my social-psychological research on rescuers of Jews during the Holocaust, I found that rescuing behavior under extreme terror is "infinitely more complex and varied than these stereotypes."[11] A woman's sense of right and wrong could be motivated by compassion and caring, which leads to taking responsibility for another life, or it could be motivated by the thought that "it is the right thing to do." As for men, some were motivated by caring and compassion for a fellow being and felt empathic towards their pain, suffering and imminent death, while others had belief in justice, and this motivated them to risk their lives for a total stranger. The stereotype of women being relegated to the kitchen would have us believe that the actions of women in rescue situations was limited to saving one or a few Jews in their home and that men were engaged in more active rescue missions outside the home. In the first instance, in order to protect a Jew at home, a rescuer had to go out to procure food, medication and other basic necessities for several years. With food ration cards and limited supplies, this was not an easy feat during wartime. In addition, suspicious neighbors, who could turn a rescuer over to the authorities, were often a major risk. Despite the dangers, some non-Jewish women organized networks that saved hundreds and thousands of lives, particularly in the rescue of children. Women in German-occupied countries risked their lives on dangerous missions to transport Jews across borders to neutral countries, and took on life-threatening courier roles to bring information, false identification certificates, or medication to save lives.

This evidence about women's altruistic behavior in life and death situations debunks the notion that men take on more risky tasks in helping situations. This idea is further confirmed by the courageous acts of women in the resistance, and on sabotage missions carried out by non-Jewish and Jewish women. With the exception of a few, such as Nadezhda Popova and Noor Inayat Khan, women in the Resistance, were not honored. Popova, was the most highly decorated combat pilot of World War II. She was one of 800,000 Soviet military women, of which 300,000 served in combat roles (a little-known fact). Popova served with the 588th Bomb Squadron, which flew at night to bomb German encampments, rear-area bases, and supply depots. Clearly, more women should have been honored along with the men in the same roles. Noor Inayat Khan, a Muslim resister, was a radio operator, and later a secret agent for the British. She was posthumously awarded the George Cross, the highest civilian decoration in the United Kingdom and other commonwealth nations.

As for Jewish women in the resistance, in the ghettos and forests, they too, did not have as much recognition as that of their male counterparts. In the post-Holocaust generation in Israel, a society that prides itself on the resistance of the Jews during the Holocaust, many Israelis knew of Abba Kovner's leadership in the uprising of the Vilna Ghetto, and of his post-war activities: and of Mordecai Anielewicz's role in the Warsaw ghetto; and of Bielski brothers who were Partisans in Byelorus

forests. Such collective memory ignores the role of courageous Jewish women who risked life and limb, and had leadership roles in combat operations and sabotage.

One exception is Hannah Senesh, a national hero in Israel. Known as "the Jewish Joan of Arc," she risked her life as a wireless operator, then as a paratrooper with the Women's Auxiliary Air Force. She parachuted into wartime Hungary on a mission to save Hungarian Jews from being deported to their death. In Israel, youngsters grow up singing her poems. When Hannah Senesh's diary was published in 1972 in English[12], Abba Eban wrote, "All the definitions of giant courage come together in Hannah's life."[13] Senesh wrote in her diary, "One needs to feel that one's life has meaning, that one is needed in this world."[14] Were it not for her poems and diary, Senesh, too, would have been forgotten, as was the case with other women.

On the other hand, Vitka Kempner was less known in Israeli society because she rarely spoke about her resistance during the Holocaust. She deferred to her husband Abba Kovner as the spokesperson for the Partisans. When she joined the Partisans in Vilna, Vitka blew up trains, and navigated six hundred Jews out of the Vilna ghetto. She maintained contact with other resistance groups, and obtained medications and other essentials. After liberation, Kempner assisted in smuggling Jews into Palestine, and later returned to Europe to carry out a revenge mission against the Germans. Thereafter, she devoted her life to living in a kibbutz in Israel, raising a family, and working as a psychologist to give hope to parents and children who were emotionally damaged. Kempner became known for her courage during and after the Holocaust, but she has not become a national symbol of heroism to the degree that her husband has become.

The same goes for Zivia Lubetkin who, in August of 1939, was one of the only women sent to a Zionist Congress in Geneva. She returned to Warsaw when Hitler and Stalin declared the Molotov Pact. Lubetkin was considered the mother and sister of the Zionist movement: she provided food, organized activities for the children, and negotiated for supplies. After the mass deportation of Jews from the Warsaw

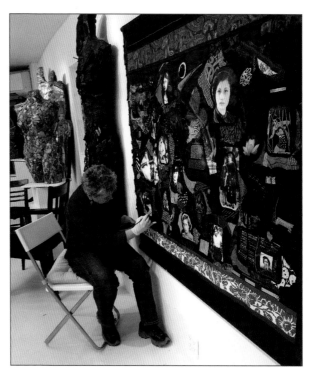

FIG. 14. Stein at work in her Tribeca studio, 2015.

ghetto on July 28, 1942, she dedicated her actions towards armed combat against the Germans. In January 1943, she was a leader in the Ghetto's underground, organizing for the uprising. She crawled through sewers, reaching the Aryan side, while 120 comrades (including Anielewicz) were killed. Lubetkin immigrated to Palestine in June 1946, where she established Kibbutz Lohamei Hageta'ot in Northern Israel, the Ghetto-Fighters Kibbutz.

It is often thought that to be a resistor, one must use weapons. However, Holocaust scholars, such as Yitzchak Mais,[15] assert that definitions of resistance varied with the changing conditions to which Jews were subjected in the evolving genocide. The celebration of some Jewish holidays while in hiding, to take one example, could also be seen as a form of resistance.

Another example was the diary that Anne Frank kept in order not to succumb to total despondency in hiding. It was the voice of this young girl, in *The Diary of Anne Frank*,[16] that introduced every youngster to what it was like under the German occupation during World War II. Despite the fact that the gory details of Anne's final months in Bergen-Belsen would be written by other witnesses many years later, her life in

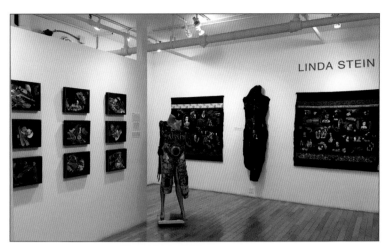

FIG. 15. Installation detail of *Holocaust Heroes: Fierce Females* at Flomenhaft Gallery, New York, 2016.

the Amsterdam attic continues to give millions of youngsters the inspiration that writing can be a form of resistance, helping people not to give up in the face of adversity.

In her diary, Anne Frank was the first one to acknowledge the courageous deeds of the unsung heroes, the rescuers – particularly of Miep Gies, who found and hid Anne's diary after the family was taken away. Frank wrote, "It is amazing how much noble, unselfish work these people are doing, risking their own lives to help save others." She continued, "Our helpers are a very good example . . . Never had we heard one word of the burden which we certainly must be to them, never had one of them complained of all the trouble we give."[17]

The words of Anne Frank and Hannah Senesh are truly powerful, but we also know that pictures often do speak louder than words. Sometimes a critical event transforms a bystander into action. In 1947, Ruth Gruber, a young American journalist who, in 1944, had already brought 1,000 Jewish orphans to Oswego, New York, heard about the British attack on the *Exodus* carrying 4,500 remnants of European Jewry to Palestine. She made her way to Cyprus and photographed the men, women and children as they were shepherded onto three prison ships. The worldwide distribution of her photographs told the story of the British treatment of the refugees. It is not a stretch of the imagination to say that these photos had influence in eliciting an empathic response from

political decision-makers to the plight of the Jews.

Another journalist who was transformed from passive bystander to brave upstander was Nancy Wake, a non-Jewish journalist living in Paris when Hitler became Chancellor of Germany on January 30, 1933. When she saw what was going on in Germany at the time – Jewish men being whipped by the SA, Brown Shirts harassing customers going into Jewish-owned stores – Wake resolved at that moment, "If I ever had a chance, I would do anything, however big or small, stupid or dangerous, to try to make things more difficult for their rotten party."[18] She became a courier for the French Resistance and played a role in the rescue of Allied soldiers trapped in France.

Unlike resisters, rescuers of Jews were focused on saving lives by hiding Jews: giving them information, false identification papers, food-ration cards, hiding places, transporting them to save havens, medical supplies and food. After interviewing approximately three hundred rescuers from all walks of life, I found that their reasons to risk their lives and that of their families varied. Some were motivated by their morality, "I couldn't live with myself if I let these people die." Others had relationships with Jews; and it was this relationship that was at the forefront of their desire to help. Some upstanders were anti-Nazi, and it was their rage against the German occupiers that was the impetus to help Jews survive in the face of imminent death. There were rescuers who were in helping professions, and they used their roles assisting in the survival of Jews. Diplomats were a separate category of rescuers who risked their careers to save lives. Finally, children were engaged by their parents to assist in rescue activities.

Once again, women rescuers are less known than their male counterparts. In the early 1960s, when Yad Vashem, Israel's National Authority for the Remembrance of the Martyrs and Heroes of the Holocaust, began honoring non-Jews who risked their lives to save Jews – without any

financial or other rewards – Oskar Schindler was one of the early recipients of recognition. By contrast, his wife Emilie, a nurse, who was working at his side to rescue more than 1,000 Jews, was not honored along with him. This omission is congruent with the invisibility of female heroism It took more than 30 years, in 1994, before Emilie Schindler was finally recognized for her own courageous deeds.

Another such rescuer who was honored is Gertrud Luckner who was a German Catholic Caritas social worker active in the peace movement. From the early days of the Third Reich, she traveled around the country, giving assistance to Jewish families. She worked with Rabbi Leo Baeck in Berlin getting Jews extra food and enabling them to leave Germany. When Luckner was caught on one of her missions and asked who told her to do what she was doing, she replied, "My Christian conscience."[19] She survived the Holocaust and continued to do interfaith work throughout her life.

It is unfortunate that Yad Vashem does not give awards to Jews who saved Jews. If that were the case, Hadassah Bimko Rosensaft would be at the top of the list. Rosensaft was a Polish Jew who studied dentistry in France before World War II. Her six-year-old son, her husband, and her parents were murdered upon arrival to Auschwitz in August 1943. Rosensaft used her position in the infirmary to provide meager medicine and care for as many inmates as she could. When she was sent to Bergen-Belsen as part of a medical team, she risked her life to keep more than one hundred children alive. After the war, she worked with the British medical team to help victims transition from a starvation diet to normalcy, and to care for the sick. She also took orphaned children to Palestine for refuge. At the World Gathering of Holocaust Survivors in 1981 in Jerusalem, I was standing near Rosensaft when a woman came up to her and said, "You saved my life." I was in tears.

Implications for the Holocaust Heroes: Fierce Females Exhibition

If we take Albert Schweitzer's thinking seriously about the importance of role models – "Example is not the main thing in influencing others. It is the only thing."[20] – we must ask: What messages are being sent to the next generation when today's youngsters are bombarded by the media with the assumption that unless one is a superstar in sports, movies, television, music – and rich – their lives are unworthy.

In contrast, Linda Stein's *Holocaust Heroes: Fierce Females* exhibition and educational initiatives, countering bullying and bigotry, and addressing female sexual abuse during the Holocaust, has the potential of making a difference on many fronts. Stein portrays, in an innovative style for the twenty-first century, those still-quieted voices of women during and immediately after the destruction of European Jewry. The exhibition takes this group of women from oblivion to visibility.

In the historiography of the study of the Holocaust a new category of people will be studied – upstanders – along with persecutors, victims, bystanders, resisters, and rescuers. The very concept of *Holocaust Heroes: Fierce Females* provides girls, young women – and, yes, men – with much-needed role-models to inspire them with the courage to act humanely in day to day situations that require stepping out of one's comfort zone. Obviously, in extreme situations, being a rescuer or resister is life-threatening. Being altruistic or moral on a daily basis is not a life-and-death choice, though speaking out against bullying and bigotry could be potentially dangerous.

The ten women chosen for the *Holocaust Heroes: Fierce Females* exhibition are but a limited number of this population. As this female-inclusive concept becomes the norm in the nomenclature of Holocaust historiography, more women will gain recognition. These ten women and thousands of others like them, deserve a place in the collective memory of the destruction of European history. In the words of Hannah Senesh:

There are stars whose radiance is visible on earth though they have long been extinct. There are people whose brilliance continues to light the world though they are no longer among the living. These lights are particularly bright when the night is dark. They light the way for [Human] kind.[21] ∎

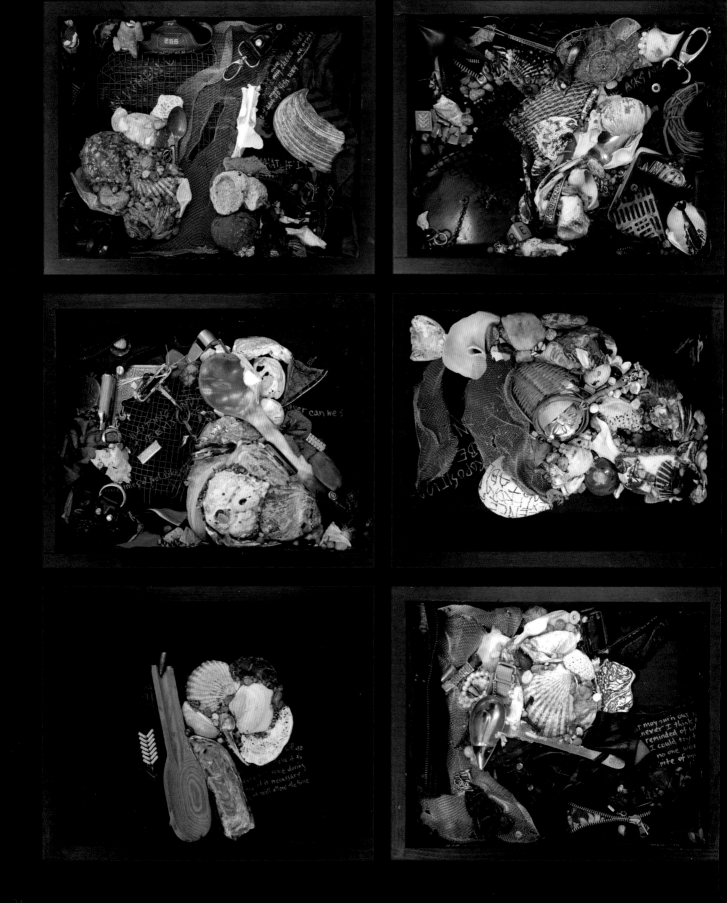

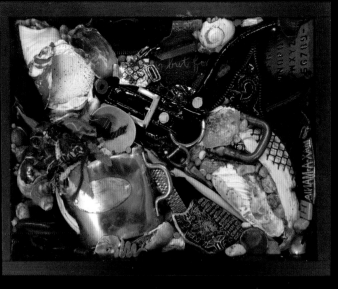

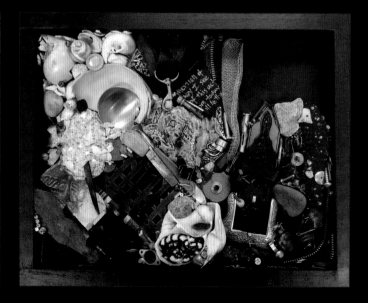

FIG. 18. From the *Spoon to Shell* series

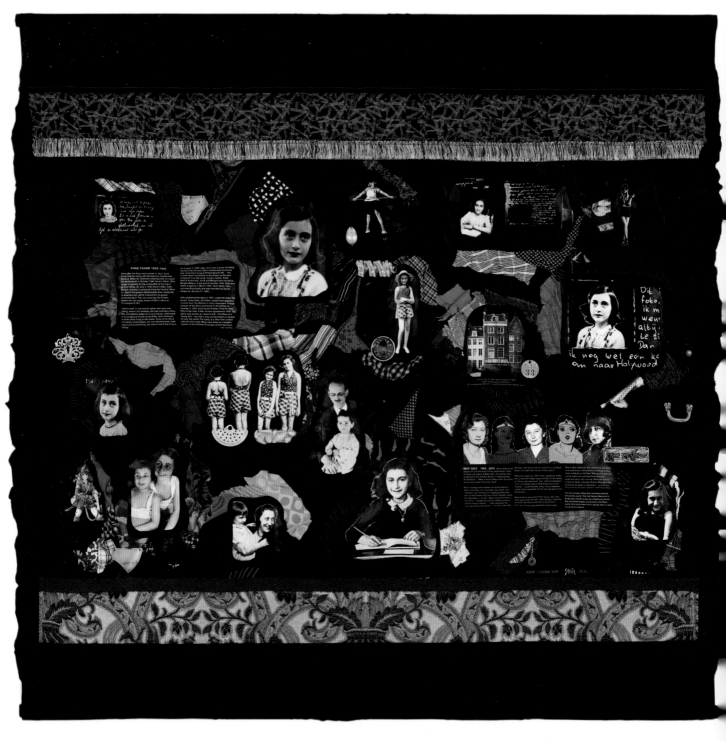

FIG. 17. *Anne Frank 839*. Leather, archival pigment on canvas, fabric, metal, zippers; 55 x 59 x 2 inches; 2015.

Anne Frank (1929–1945)

Anne Frank, a diarist and writer, was one of the most discussed Jewish victims of the Holocaust. Her wartime diary, "The Diary of a Young Girl", has been the basis for several plays and films. She represents the many brave girls during this period and exemplifies the loss and legacy of the 1.5 million Jewish children murdered during the Shoah. Anne Frank was born in Germany and during the time of the Holocaust lived in Amsterdam.

ANNE FRANK
A Girl and a Symbol

David Barnouw

How do we know Anne Frank? Do we know her because of her famous diary, or from the 1950s American play? Or, do we know her from visiting one of the hundreds of Anne Frank exhibitions? Or, perhaps, we know her from a visit to the shrine at the Prinsengracht in Amsterdam?

These are the facts: Anneliese Marie Frank was born in Frankfurt am Main, Germany, in 1929 into an assimilated Jewish family. Hitler's rise to power forced the Frank family to go abroad to the Netherlands. Her father, Otto Frank, knew, and everybody expected, that the country would remain neutral.

The Franks felt safe in this small, rather conservative, country. Anne and her older sister, Margot, received a liberal upbringing at home and at school. When the German troops invaded the Netherlands in the spring of 1940, everything changed because anti-Jewish measures were heightened. Otto Frank tried to flee to the United States, but did not succeed. When the Germans summoned Margot to "work" in Germany, the family knew they had to go into hiding. "So there we were, Father, Mother and I, walking in the pouring rain, each of us with a school bag and a shopping bag filled to the brim with the most varied assortment of items."[1] The Franks were on their way to a hiding place at the Prinsengracht in Amsterdam, now a famous shrine visited by more than a million people each year. It was here that we find Anne Frank writing one of the most powerful accounts of the war and the Holocaust. But there is even more: additionally, her diary is about the life of a teenager full of curiosity. It is about hope and love. There is the war, of course, and the family is in hiding because they are Jews, but Anne writes pages and pages without mentioning these facts. We know so much about her 756 days in hiding because of this diary, which for millions of people since the 1950s, has been the first, and only book read about the persecution of the Jews.

For teenagers it represents the story of a high-spirited girl whose energetic personality pulled her through moments of despair and loneliness.

> This morning, when I had nothing to do, I turned over some of the pages of my diary and several times I came across letters dealing with the subject 'Mummy' in such a vehement way that it quite shocked me and I asked

myself: 'Anne, is it really you who mentioned hate, oh, Anne, how could you? (January 2, 1944)[2]

Anne was close to her father and often quarreled with her mother (regretting it later). People can identify with Anne Frank, with or without the anti-Jewish war of which she became a victim.

Perceptions of Anne Frank have been changing over the years: First, in the Netherlands, we see her as a victim of the Holocaust; in the 1950s, on the New York Broadway stage, we see her turned her into a symbol for injustice worldwide. On Broadway, Anne lost her *Jewishness* as the Holocaust was conveniently left out of her story, overtaken with crimes against *humanity*. At the end of the 20th century she became, again, a symbol of the Holocaust, due to the rising interest and social consciousness about this terrible episode of modern history.

Now more people are identifying themselves with Anne in a very personal way. Young girls have always mentioned the similarity between themselves and Anne from the first time they read her diary, and that is no surprise. But nowadays, the identification is political: In the queue of people waiting to visit the Anne Frank House in Amsterdam, an African-American man from Alabama speaks of the similarities

of oppression between Blacks and Jews; Two monks from Tibet argue that Anne's struggle is comparable to the Tibetan struggle; and a gay man from Paraguay relates connections between his life experience and that of Anne's. The story of Anne Frank has become personal and central to so many around the world.

In the first 30 years after the 1947 publication of *A Diary of a Young Girl* in the Netherlands, Otto Frank acted as the translator of Anne's thoughts. When Frances Goodrich and Albert Hackett began writing the play in the mid-1950s, they received a letter from Otto Frank explaining that the playwrights should not concentrate on the Jewish aspect. Frank said that Anne's ideas were universal and that had to be the main focus: to show the world the terrible effects of discrimination, hate and persecution. When Otto Frank answered thousands of letters from readers, he always mentioned that universal message.

When people asked how life really was in the hiding place, he just said, "Read the diary." Otto Frank was the only one of this family of four who survived, and those who helped them during the war remained relatively silent until after 1980 when Otto Frank died. Curious readers and visitors of the Anne Frank House then began asking the frank protector, Miep Gies, more questions.

Miep Gies was born Hermine Santruschitz in Austria in 1909. After World War I she traveled to the Netherlands, like a lot of other Austrian children. The country had been neutral during World War I and had invited children affected by the war to temporarily stay in the Netherlands to become healthy and strong again. These children generally stayed for half a year with foster parents, and then returned to Austria. Miep Gies stayed longer because she was ill and did not mind staying with her new Dutch family. The Netherlands remained her home until her death in 2010.

Gies was bilingual in German and Dutch, and in 1933, she became secretary of the Opekta-firm, the Dutch branch of a German firm with the same name. Otto Frank was the director of this small company, and Miep, who started at the information desk, soon took on a more general administrative role. A few years later, Miep, and

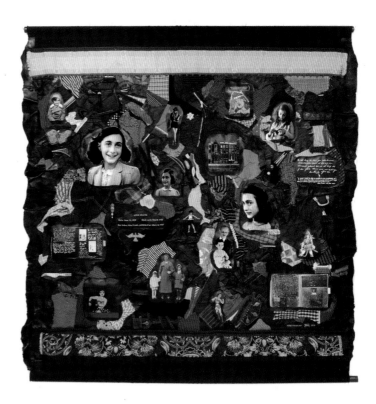

FIG. 18. *Anne Frank 808.* Leather, archival pigment on canvas, fabric, metal, zippers; 55 x 59 x 2 inches; 2015. Collection of Melva Bucksbaum and Raymond Learsy.

later her fiancé, became close friends of the Frank family, often visiting at their home.

As Gies was still Austrian, she ran into trouble when Austria was annexed by Germany in 1938, because she was now a German citizen. After the annexation she was ordered to return to Austria, her home country. She had already refused to join a Nazi organization, and her marriage to Jan Gies saved her, because after marriage she automatically became a Dutch citizen.

Since Otto Frank was afraid the Germans would confiscate his firm, he decided to officially step down and to transfer the ownership to non-Jewish friends. When that happened at the end of 1941, Jan Gies became one of the directors.

In the spring of 1942, Otto Frank confided to Miep that he and his family would go into hiding since the situation for Jews was worsening daily. Another family, the Van Daan's, would join them with their one son. Otto Frank explained that the hiding place would be in the back of his office at the Prinsengracht. When Miep supported the plan, Otto Frank asked her if she could take care of them, even if the German punishment might be severe. She consented, explaining later that Otto Frank had been a good employer to her before the war and she could not refuse his request for help. She did not see herself as altruistic, and one wonders what she might have done if Otto Frank had been a bad employer.

A few months later the two families went into hiding, later followed by the dentist Fritz Pfeffer. Known as "Dussel," he shared a room with Anne, who was highly critical of him. Miep Gies and three other helpers took care of them, acting as the link between the Jews in hiding and the world outside.

These extremely brave citizens were hardly acknowledged as Resistance "fighters" after the war. Women in particular were merely seen as "helpers," and until recently the only female heroes were the secret agents parachuted into occupied France. But even they were considered "helping" the male Resistance fighters. In one way, this perception was an advantage, as the Germans underestimated the effective capabilities of women in joining the Resistance.

Seven years after the death of Otto Frank, Miep Gies would publish her book *Anne Frank Remembered: The Story of the Woman Who Helped to Hide the Frank Family.*[3] It was a modest account, just like its author. The belief that people are truly good at heart has fewer adherents in the 21st century than it did in the 1950s. Yet it is primarily Anne Frank's optimism and *joie de vivre* that will continue to attract new readers and new visitors to her story. ∎

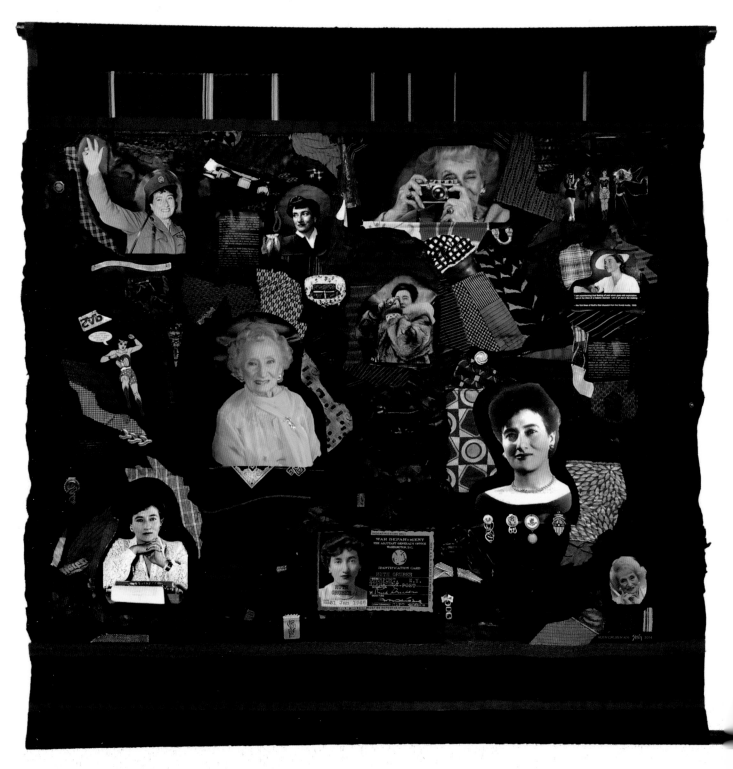

FIG. 19. *Ruth Gruber 805.* Leather, archival pigment on canvas, fabric, metal, zippers; 57 x 57¼ x 2 inches; 2015.

Ruth Gruber (1911–)

As an American journalist, photographer, writer, humanitarian and a former United States government official, Gruber traveled throughout post-liberation Europe to help, write about, and photograph Holocaust survivor refugees. Born USA .

RUTH GRUBER
My Hero

Patti Askwith Kenner

Ruth Gruber is my hero. She is the role model who has inspired me to go places in my life that I would never have dared to go. Ruth Gruber is one of my best friends. I call myself her "surrogate daughter."

About 20 years ago, as co-chair for the Museum of Jewish Heritage – A Living Memorial to the Holocaust, I was looking for a speaker for the Spring Women's Luncheon, and I was introduced to a lovely, well spoken, intelligent but tiny, elderly woman. I was impressed immediately but was not certain that this petite woman could get the attention of 500 women. Well, was I wrong! Ruth captured the minds and hearts of every person in the ballroom of the Pierre Hotel. Her story was set during World War II and her secret mission, as special assistant to Secretary of the Interior, Harold Ickes, was to accompany 1000 refugees from Italy to a camp in Oswego, New York, as guests of FDR and the government of the United States.[1] These were people who had escaped concentration camps and ghettos, and they were the first ones to tell their stories to the world, through Ruth, about their harrowing experiences. Ruth had written *Haven* telling their stories in detail. We all went home with her book in hand, mesmerized and anxious to read the rest of her passionate true story escorting these traumatized people on the military transport ship *Henry Gibbons* to the safety of America.

After that, I tried to be in Ruth's company whenever I could. I attended lectures she gave for Hadassah and United Jewish Appeal (UJA). I brought her photography exhibit to the Museum of Jewish Heritage and invited her to speak each time she wrote a new book. The latest of her nineteen books, and most encompassing with 190 of her own photographs, is *Witness: One of the Great Correspondents of the Twentieth Century Tells Her Story.*

Who is this amazing, tiny, brilliant woman, Ruth Gruber, and how has she become such a giant? Ruth Gruber was born in Brooklyn, New York, on September 30, 1911. She received a B.A. from New York University in three years, a master's degree from University of Wisconsin a year later, and a Ph.D. from the University of Cologne (magna cum laude) one year after that, becoming, at age 20, the youngest Ph.D. in the world, and making headlines on the front page of *The New York Times.* Her thesis was on a little known (in America, though well known in Europe) writer named Virginia Woolf (whom Ruth met at her home in the Bloomsbury area of

FIG. 20. Ruth Gruber and Linda Stein, 2014.

London some years later). While in Germany, Ruth attended a Hitler rally and actually stood near The Fuhrer. She was horrified by his message of hate, "Death to the Jews!" "Death to America!" She told me she thought, "These are the words of a mad man!" She said she would never forget the horrible sound of his voice and his words!

At age 24, Ruth became an international correspondent for *The New York Herald Tribune* and was the first journalist allowed in the Soviet Arctic. Six years later, as special assistant to Secretary of the Interior Harold Ickes, she traveled to the Alaska Territory "to be his eyes and ears" and to report back on conditions, with the possibility of World War II veterans homesteading there after the war.

In 1944, Ickes assigned her the mission of escorting the 1000 refugees she described at the museum luncheon and in her book *Haven.* It was a life changing experience for Ruth. From that moment on, she said, "I knew I would be, not just an Arctic expert, but I wanted my life to be involved with rescue."

After the war, Ruth was invited to be *The New York Post* correspondent visiting displaced persons camps, interviewing survivors who, overwhelmingly, wanted to settle in Palestine. She also sat in the front row of the Nuremberg Trials, where she watched the murderers of the Jewish people be sentenced to hanging. She

said it was an experience she would never forget. Ruth then traveled for *The Herald Tribune* with the United Nations Special Commission on Palestine (UNSCOP), visiting displaced persons camps and again interviewing survivors. In 1947, while Ruth was traveling with UNSCOP, she learned of the attack by the British on the ship *Exodus 1947*, as it was moving outside territorial waters to Haifa to bring 4,500 Jewish refugees to safety. She rushed to the scene and reported "the ship looks like a matchbox splintered by a nutcracker." Ruth, representing the entire American press, photographed the refugees as they were herded onto three prison ships. As an act of defiance, they painted a swastika on the British Union Jack and Ruth sent this photograph around the world. Together with the UNSCOP recommendations and Ruth's photographs, the world saw the British treatment of victims of the Holocaust. Ruth's photos were powerful images contributing to the founding of Israel.

Although Ruth studied both German and journalism to prepare for her life's work, she never took a photography class. She once met the great photographer Edward Steichen, who said to her," Ruth, take pictures with your heart," and she followed his advice. In fact, the International Center of Photography was so impressed with Ruth's collection of work that, after seeing her photographs in *Witness*, the ICP mounted a solo traveling exhibition, *Ruth*

Gruber: Photojournalist, which is still traveling around the United States.[2]

You now have a glimpse into the life of my dear friend Ruth Gruber, a giant of a tiny woman who has changed the world for good. She is a role model for all her friends and family and for anyone who meets her. However, for me, it was a little different. For all the years I have been lucky enough to know Ruth Gruber, people have been saying that they wanted to make a film on her life. And, of course, I encouraged everyone who suggested it, because I also believed that her story should be told. However, no one saw the idea through.

Consequently, on her 97th birthday, I announced to Ruth that a film should be made about her life and I was going to do it.[3] Being so close to Ruth and watching how she led her life, by allowing no obstacles to stand in her way, inspired me to know that I had a chance to do something so important as to introduce Ruth Gruber to the world through a film.

I first approached Ruth's "other surrogate daughter" Doris Schechter to ask her if she would like to make the film with me.[4] Neither of us knew anything about making a film, but we knew Zeva Oelbaum, a woman who made a documentary we liked; and so we hired her to be our producer, who then recommended Bob Richman to be our Director. We hired Sabine Krayenbuehl to be our editor. We hired the National Center for Jewish Film at Brandeis University to be our fiscal sponsor and solicited a hundred friends who each made tax-deductible donations of $25 to $100,000.

I told Zeva she had one year to make the film because Ruth was elderly. With Doris, Denise Benmosche and me as executive producers,[5] the film *Ahead of Time: The Extraordinary Journey of Ruth Gruber* opened at the Toronto International Film Festival and went on to win seven "Best Documentary" awards. The film travels to festivals, synagogues, Jewish Community Centers, universities and high schools in the United States and throughout the world spreading Ruth's message to fight injustice.[6] Ruth attended many screenings in the past, but now, at the age of 104, we represent her.

Ruth would say that each of us has something special within ourselves to make a difference in the world and we have to look inside to find it. She says that her tools were her camera and her words, and that is what she used to fight injustice. She would say that each of us has the ability to help make peace and to fight injustice with our own tools. We just have to find them and use them to make the world a more humane place. ■

 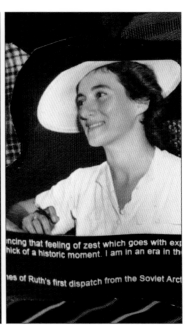

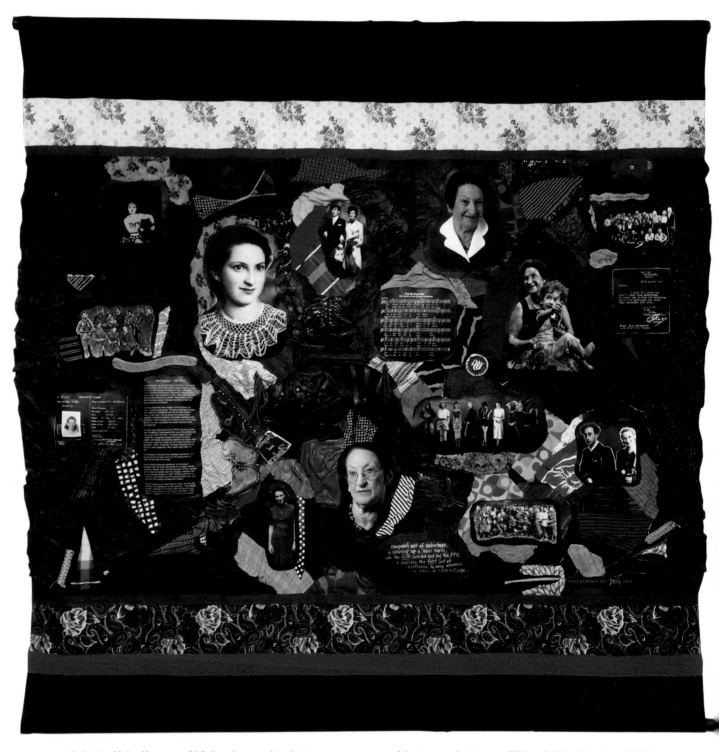

FIG. 21. *Vitka Kempner 815*. Leather, archival pigment on canvas, fabric, metal, zippers; 56½ x 58½ x 2 inches; 2015.

Vitka Kempner (1920–2012)

Kempner was a leader of the United Partisan Organization's armed resistance in the Vilna ghetto. She fought alongside founder Abba Kovner, whom she later married. Fearless in combat, she was the first woman to play a role in blowing up a Nazi train. Born: Poland. During Holocaust: Poland .

VITKA KEMPNER
Courageous and Modest

Michael Kovner interviewed by Eva Fogelman

Vitka Kempner's heroism was not well known outside her immediate circle of Partisans until the release of the documentary, "Partisans of Vilna," in 1986.[1] Vitka often stood in the shadow of her husband, Abba Kovner, the leader of the Partisans in Vilna, with whom she worked closely in fighting against the German occupiers during World War II. Abba was the talker; Vitka was the doer. When Abba died in 1987, and Rozka Korczak, a close partisan comrade died a few months later in 1988, Vitka decided to tell her story to her cousin Rich Cohen.[2] She explained to Cohen that if she kept silent, the story would die with her.

Since then, Vitka's story can be found in many books and archives. She has been the subject of several biographies, including one by Michael Kovner. Her archives are available at Yad Vashem (oral history videos), the archives at Givat Haviva and at Kibbutz Ein ha-Horesh, which was her home until her death in 2012.[3]

Vitka was the daughter of tailors who kept a small retail shop in Kalish, Poland. Her parents were Zionists. From an early age, Vitka was drawn to the right wing Zionist youth movement, Betar, a group that had a militaristic cast to it. In her last year of high school, friends convinced her to join Ha-Shomer ha-Tza'ir, a Zionist movement of the Left. She continued her youth movement affiliation after moving to Warsaw an enrolling in Jewish studies at a seminary. When the Germans invaded Warsaw, however, Vitka returned to her hometown.

This interview with Vitka's son, Michael Kovner, who is an artist in Jerusalem, presents us with a first hand account as passed on to the second generation.[4]

Eva Fogelman (EF): When did you become aware of your mother's heroic deeds?
Michael Kovner (MK): I was aware of my mother's activities from an early age. My mother thought of herself as a fighter, not as a survivor. The people who came to visit us were Partisans. Every Saturday there were Partisans who came to visit, and they would talk among themselves. I would eavesdrop and hear her stories. Ruzka, Mina, Yulek, Jessa, Zelda and Chayka [Knesset member Chayka Grossman]. I learned that among the Partisans, men and women were equal.

EF: How did your mother become a hero among the Partisans of Vilna?

MK: When Germany invaded Kalish in western Poland, every Jew was asked to come to the main street to be deported. Her parents said: "Let's go!" She replied: "You go, I won't go!" It is at this point that she started going east to Vilna. She saw an option and ran away with her brother, Baruch, who joined Mordecai Anielewicz to fight in the Warsaw ghetto uprising and was killed. This was also the last time she saw her parents, and did not know exactly when or how they were killed.

My mother had a certificate to go to Palestine, much valued, but she decided to stay and fight. That was truly very brave. She did not want to leave her people behind. In Vilna, she lived outside the ghetto. She could have saved herself. But she gave up her chance to survive because she wanted to be with her peers of Ha-Shomer ha-Tza'ir. She did not think about how to survive but rather how to fight. Aviva Kempner reminds me that my mother said: "We never thought we would live, it was just a choice on how to die."

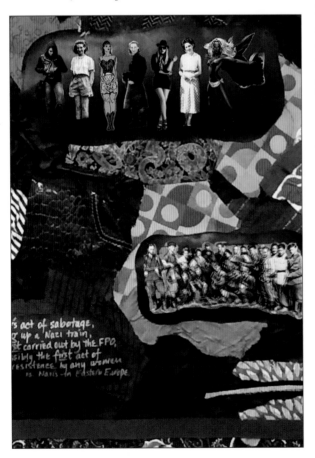

EF: Is there any particular story that stands out?

MK: Yes, two stories. One story is about how she blew up the train in July 1942. Vitka blew up the first German train that killed more than 200 German soldiers. It was known that if a commander sends a girl on the most dangerous mission, he is signaling that she is his girl. At this point she became Abba's girl. She spent a few nights surveying the best place to blow up a train. One night, she was caught in a cross-fire. It turned out to be a shooting range for Germans. She explained that she was lost, and they helped her find her way back to Vilna. A few nights later, she led a group of Jewish fighters and hooked up a pipe onto the rails. She connected a fuse from the bomb along the rails to the detonator and escaped into the woods. When the train went over the detonator they heard a big blast and saw flames. Germans who were not killed jumped off the train and started shooting and Vitka led the group back to a ghetto cellar.

The other story is that after one raid, the non-Jewish Partisans took the weapons of the Jewish Partisans to make fun of them. My mother took a white horse and rode it to meet the brigadier of the Partisans and demanded that they return the weapons. After this incident everyone appreciated the Jewish Partisans, and as for Vitka – she could not be put down!

In the ghetto there were thousands of people, so each person's behavior did not affect the whole operation. But in the Partisans there were fewer people, so what other people thought about you was very important. In the Partisans, if you made a mistake, the whole battalion knew about it, and it had an impact.

My mother knew how to navigate. She always found her way back. One day she was caught and taken in a vehicle to Gestapo headquarters. She said to herself, "Oh, this is my end." She blurted out: "When the Red Army will free us, I will tell the Red Army your name and they won't harm you." They let her go. This was my mother. She had good intuition. The Partisans respected her. Her friends would say that she didn't need to stop to eat and she didn't need sleep. She was admired for her strength.

One day I went to a banker in Bank Leumi, and he said: "There was Abba and Ruzka but

your mother was something else." Everyone said she was a brave woman. Everyone spoke about her in the same way. Most of the women in the Partisans stayed in the field and cooked. They were not engaged in fighting. The commander did not want them because it was a burden to take the women because they could not carry heavy equipment.

My mother was notorious for not knowing how to drink vodka. The non-Jewish Partisans were tough people and they would get angry when she refused to join them for a drink.

She looked more Jewish than the others even though she dyed her hair, so she made sure to walk like a Pole.

EF: Could you elaborate on your mother's role in the Partisans?
MK: My mother moved in and out of the Vilna ghetto. When the Jews in the ghetto were liquidated and sent to be killed en masse at Ponar, she found hiding places for some of the Partisans. Then my mother smuggled and directed 600 Jews out of the Vilna ghetto into the woods. As commander of the patrol section of the Jewish Partisans, she gathered intelligence and maintained contacts with resistance groups in the city, assisted with procuring medication, and, of course, she led her division on combat operations and sabotage.

EF: What did your mother do after liberation?
MK: My mother was the first partisan to reach liberated Vilna, where she encountered the Jewish Soviet soldiers. She was awarded the highest badge of courage in the USSR. My father formed the Organization of Eastern European Survivors and arranged the "B'richa".[5] My mother's role was to smuggle refugees across the border to Romania. In a very chaotic time she found a way to get from border to border to get to Palestine. Abba went back to Europe to organize a revenge operation, and she remained alone in Palestine.

EF: How was your mother as a mother?
MK: I grew up on kibbutz Ein Ha-Horesh and remember my mother being very ill. When I was three years old she contracted tuberculosis and I could not see her for a year. The following year

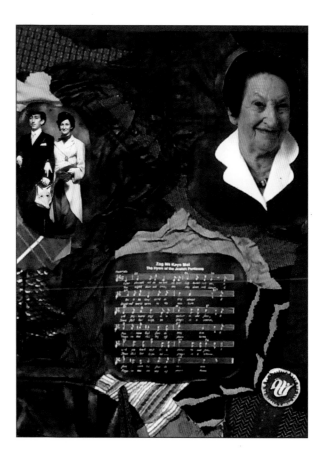

I could only see her from afar. She was warm and supportive. She thought I was the best young man and the best artist. She gave me all the support she could. She never gave up a fight for the truth. She believed in the Ha-Shomer ha-Tza'ir model of communal education. She tutored children on the kibbutz, and at the age of 45, my mother went on to study for a doctorate in psychology. She developed a new form of therapy, "non-verbal therapy by color," enabling troubled children to speak with colors. She always focused on the children's strengths, rather than their pathology, and gave hope to their parents that change is possible.

EF: How do you think your mother's heroism has shaped your life?
MK: Rav Nachman of Bratslav said: "Whoever speaks the truth it is as if he has spoken with God." My mother's words came from the heart and were clear and simple truths. I, too, seek the truth. My mother gave me inspiration. As were my mother and father, I am committed to living in Israel, as are my children and grandchildren. ∎

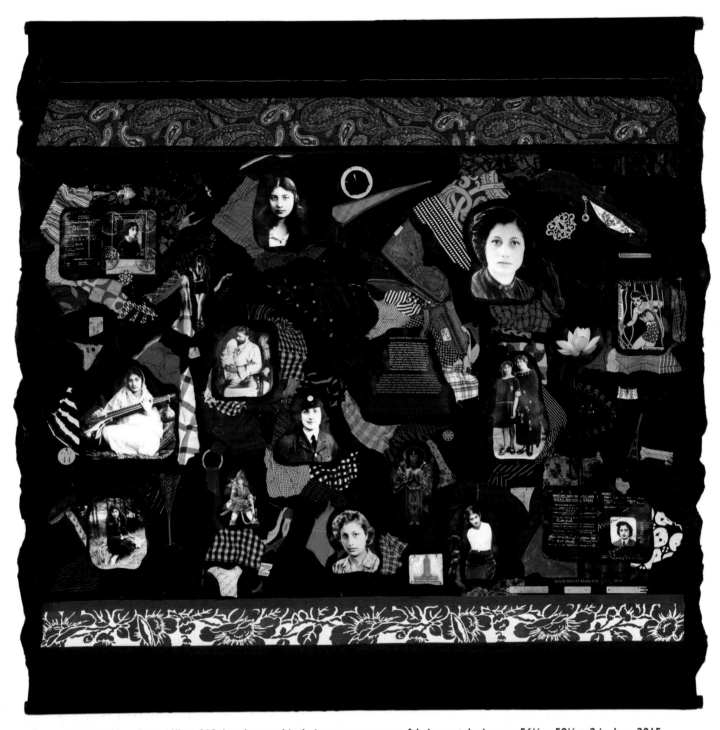

FIG. 22. *Noor Inayat Khan 813*. Leather, archival pigment on canvas, fabric, metal, zippers; 56½ x 58½ x 2 inches; 2015.

Noor Inayat Khan (1914–1944)

A Special Operations Executive (SOE) agent, Khan became the first female radio operator to be sent from Britain to aid the French resistance. Born: Russia. During Holocaust: Britain, France, Germany (from 1943 October to 1944 September, Noor was in a prison in Pforzheim and then Dachau).

ZIVIA LUBETKIN
Tough and Compassionate

Dalia Ofer

For Israelis, including myself, who grew up during the 1950s and 1960s, Zivia Lubetkin was an icon. Her personality and life story embodied the image of heroism during the Holocaust, as understood in Israel during the first decades after World War II. I never met her personally, but I vividly remember a talk she delivered to students of the Hebrew University High School a number of years before she passed away. Lubetkin talked in a low voice, and the hall, filled with some 300 teenagers, was electrified. They listened eagerly to a complex message she presented about the meaning of resistance during the Holocaust and the difficulties of Holocaust remembrance. Her talk was a source of inspiration and engendered further talks and deliberation among the students.

People who knew Lubetkin from Poland and during the Holocaust recalled: "She had blazing eyes and a penetrating glance, was simple and direct, demanding the maximum of others and of herself. For her, thought and action were one."[1] Let us look back at her biography and ask what in her personality enabled her to act as she did and why she became such a prominent figure in the pantheon of Jewish heroes during the Holocaust. Was she gifted with the personality of a leader, or was it the trying years of the Holocaust that transformed her?

Born on November 9, 1914 to a well-to-do, traditional Jewish family, in the town of Beten in eastern Poland, Zivia Lubetkin was one of six girls and one brother. During the Holocaust, both parents were murdered, together with the rest of the community, in the summer of 1942.

Lubetkin was a member of the Zionist-Socialist youth movement Freiheit (Freedom). In 1934, she left home to join the first training farms (hakhsharah) for youngsters preparing for kibbutz life in Palestine. Since her parents did not approve, she left home without their blessing. Four years later, she was sent to join the Kielce kibbutz, a major training center of the movement, hoping to conclude training for immigration to Palestine. She was among the initiators of the union between Freiheit and the Young Halutz (Young Pioneers), who also trained and prepared youngsters for Palestine. When the new movement, Dror, was established, she was summoned to Warsaw to direct the network of training farms in Poland. This assignment earned her leadership status and admiration from both the young pioneers and her peers.

In August 1939, she was sent to Geneva as a Labor bloc delegate to the

21st Zionist Congress. Meeting with delegates from Palestine, whom she greatly admired, was a source of inspiration. She longed to make aliyah (immigration to Palestine) and join a kibbutz. But when news reached Geneva of the Ribbentrop-Molotov pact, the non-aggression pact between Hitler and Stalin, Lubetkin and her colleagues returned to Warsaw. Following the German occupation of Poland, Lubetkin, together with a few other leaders of the movement, fled to the east and found herself under Soviet occupation. She reached Soviet-controlled Lvov and participated in the movement's underground activities there, as the Zionist movement was banned in Soviet territories. However, Lubetkin and other members of the Dror movement were concerned about the fate of Dror in occupied Poland, and decided to return to Warsaw. In January 1940, she reached Warsaw to renew the movement's activities with Yitzhak Cukierman (nom-de-guerre "Antek"), who later became her partner. Dror House at 34 Dzielna Street, which housed a public kitchen, served as an underground center of support and information for the members of Dror and other Zionist movements.

I suggest dividing Lubetkin's activities in the ghetto into three different periods: the first, from January 1940 to January 1942; the second, to the end of the mass deportation from Warsaw in September 1942; the third, ending on May 10, 1943, with the destruction of the ghetto and Lubetkin's escape to the Aryan side. In each of these three periods, Lubetkin was a leader who responded to the needs and trials of Dror members and others. The first, includes before the Jews were forced into the ghetto in November 1940. These were months of uncertainty, endless anti-Jewish rules that destroyed the Jews economically, the barring of Jewish children from schools, and the ever-growing fear of being in the streets.

The move to the ghetto, in the second period, increased misery and anxiety. During 1941, starvation and death plagued the Jews in the ghetto as the Germans forced waves of more than 150,000 deportees into the limited space, overcrowding it beyond capacity. Lubetkin fought to provide food and housing for movement members, and encouraged them to initiate activities with destitute youth and others who desperately needed guidance and assistance. She negotiated with the American Jewish Joint Distribution Committee, the self-help organization in the ghetto CENTOS (Centrala Towarzystwa Opieki nad Sierotami), the Judenrat, and anyone who could provide supplies. She was quite successful. Survivors of the movement say that Zivia was the mother and sister of the movement, providing encouragement, warmth, and a listening ear, sharing values and hopes for a decent future. That is how the late Israel Gutman, a survivor of the ghetto and a distinguished historian of the Holocaust, remembered her.[2] Bella Gutterman, in her seminal biography of Zivia Lubetkin, quoted from a diary of Hannah, a member of Dror:

> Zivia was in the center of the doer and doing. In the corridors of the JDC she stood and dealt with handling our welfare . . . in the passageways of the community, exhaustingly dealing with obtaining aid for the comrades, transit permits, exemption permits from labor camps, fighting for our principles in meetings of institution heads, arranging our pioneer issues. Sometimes there would be a weak "I am worn out" – and again with renewed vigor, back to her work . . . Zivia always looked awful, quite simply, she had not time to eat. A friend of ours in town told me once: "Take care of your Zivia, she won't hold out for long under these conditions."[3]

Information came of the systematic killing of Jews in Vilna and Chelmno. The efforts to maintain the movement and assist its members to endure the suffering of the war were no longer relevant. How to combat the Nazi policy of annihilation was now the central issue. Lubetkin later testified in the Eichmann trial in Jerusalem in 1961:

After we heard about Vilna on the one hand and about Chelmno on the other, we realized this was indeed systematic. . . . We stopped our cultural activities . . . and all our work was now dedicated to active defense.[4]

The move, from activities that cherished life and hope in the direction of a fighting underground, was a painful and slow process. Lubetkin was among the founders of the anti-Fascist bloc in March 1942, the first organization in the Warsaw Ghetto to engage in armed combat against the Germans. However, only

after the first week of mass deportations from the Warsaw ghetto, on July 28, 1942, did Zivia Lubetkin, together with her comrades, reach the point of no return. No more planning and deliberations, but action. She was one of the founders of the Jewish Fighting Organization (Zydowska Organizacja Bojowa or ZOB), a member of its command, and among those who planned its organization. Nevertheless, ZOB was unable to be effective during the weeks of the great deportation as its late establishment, the lack of arms, and the capture and killing of its two major leaders, ended in despair. Lubetkin, and many members of the underground still alive after the halt in the deportations in September 1942 felt that their lives had no value. Efforts to fight the Germans and save Jewish honor had failed. More than 300,000 Jews were killed or deported to Treblinka, while some 60,000 remained in the ghetto. It became clear to Lubetkin and the rest of the underground members that the next deportations were only a question of time. Why continue living?

The idea of setting afire the remains of the ghetto, and committing a collective suicide, was raised. In desperation, Zivia Lubetkin supported it. This was a breaking point in Lubetkin's spirit. But she and the other supporters of the idea were slowly convinced that it was too early for such an act of despair. The goal should remain fighting the Germans and defending the honor of the murdered Jews. They reasoned that the Germans would come again for a final murderous raid on the remaining Jews, and they should dedicate their actions towards the last fight.

This is the beginning of the third period that ended with the ghetto uprising and its burning by the Germans. Lubetkin played a central role in unifying the different political groups in the ghetto, bringing together Zionists and anti-Zionists such as the Bund. She was a member of the Jewish National Committee (Zydowski Komitet Narodowy), the ZOB's political leadership, as well as a member of the Jewish Coordination Committee that worked with the Bund. Lubetkin participated in the ZOB's first resistance operation in January 1943, which raised great hopes that the resistance movement would be able to mount a real uprising when the Germans came to complete the deportation.

From January 1943, Lubetkin was a central figure in the ghetto underground's planning for the uprising. The leadership endeavored to get aid from the Polish underground as the entire population prepared for the final battle. People constructed elaborate hideouts for when the German troops entered the ghetto. Under the leadership of Lubetkin and Mordechai Anielewizc, the fighters organized in small groups in bunkers and on roofs to attack the Germans from different points.

After the first days of combat during the April 1943 uprising, the fighters were trapped in the bombed and burning ghetto. Lubetkin, who was responsible for connection between the groups spread throughout the ghetto, moved around the various bunkers, maintaining contact between the leadership and the fighters who remained in the burning ghetto. She was aware of the horrible condition of the fighters and others in the bunkers and understood that urgent help was needed. The day before the Germans discovered the ZOB headquarters at 18 Mila Street, the command decided that Lubetkin should set out to find a connection to the outside via the sewage tunnels that led to the Aryan side. On May 10, 1943, she had been crawling and walking through the sewers for 48 hours with a small number fighters, their legs sunk in filthy water. Anielewizc, and the 120 remaining fighters did not survive. To the end of her days, Zivia was haunted by the thought that she had abandoned her friends.

Until the end of the war, Lubetkin hid in Polish Warsaw, serving in the underground and fighting in the rebellion there from August to October 1944, part of a ZOB company that joined the fighting units of the Polish underground. Together with the surviving fighters, she was rescued In November 1944 from a hideout by Polish soldiers of the Red Army.

After the end of the war in Poland and until Lubetkin immigrated to Palestine in June 1946, she dedicated herself to assisting survivors. She became a source of hope and support for many. The trials she faced during the ghetto years molded her character with toughness and compassion alike. These determined the two faces of her leadership, both mother, and strong, demanding commander. ■

FIG. 24. *Gertrud Luckner 843*. Leather, archival pigment on canvas, fabric, metal, zippers; 54½ x 59 x 2 inches; 2015.

Gertrud Luckner (1900–1995)

Luckner led Freiburg Catholics, with money received from the archbishop, smuggling out Jews over the Swiss border and delivering messages from the beleaguered Jewish Community. After the war, Luckner devoted herself to furthering understanding between Jews and Christians. Born: England During Holocaust: Germany.

GERTRUD LUCKNER
Devoted to Christian-Jewish Reconciliation

Carol Rittner

It seems almost a cliché to call Gertrud Luckner extraordinary, but that is what she was. When most people in Nazi-dominated Germany were turning their backs on their Jewish neighbors and colleagues, Gertrud Luckner was looking for ways to help them. When most ordinary Germans closed their eyes to the fact that Jews were being forced out of Nazi Germany, Gertrud Luckner was looking for ways to connect them with her contacts in England and elsewhere so they might find a place of refuge. When so many ordinary citizens in Nazi Germany refused to extend a helping hand to infirm and elderly Jews who had no one to look after them, Gertrud Luckner conspired with her friend Rabbi Leo Baeck in Berlin to visit them and to bring them food and medicine so they would not feel alone and abandoned. And when the Nazis began to arrest and deport the Jews of Germany to concentration camps in Poland, Gertrud Luckner, a slightly built, intelligent and fearless woman, risked her life to help hide and save Jewish men, women and children.

Who was this woman who refused to be daunted by the Nazis and the Holocaust? Who was this Catholic woman who refused to be infected with the theological anti-Judaism coursing through her religious tradition and the racist anti-Semitism animating her society? And who was this German woman of courage who, after 1945, refused to give in to the physical and psychological after-effects she endured following years of Nazi harassment, torment and imprisonment?

Gertrud Luckner was born to German parents in Liverpool, England on September 26, 1900. They returned to Germany when Gertrud was six years old. Her parents, still quite young, died after World War I. She had no brothers or sisters. She once said, "My family was a small part of my life."[1]

The war, however, was not a small part of her life. It impacted her greatly, and while she missed out on some regular schooling because of the war, she developed an early and abiding interest in social welfare and international solidarity. "I was always against war," she said, and "so I got involved with a very international group. I received my degree from Frankfurt am Main in 1920, in the political science department."[2] Gertrud went on to study economics, with a specialization in social welfare, in Birmingham, England (at a Quaker college for religious and social work). She returned to Germany in 1931, shocked by the popular support Hitler and the Nazis had, "appalled at the Nazi vocabulary of women students

in Freiburg."[3] She obtained her doctorate from the University of Freiburg in 1938, just as Hitler and the Nazis were consolidating their power, stepping up their harassment and persecution of Jews in Germany, and preparing for all-out war in Europe.

A trained social worker, Luckner worked with the German Catholic Caritas organization in Freiburg. She was active in the German resistance to Nazism and was also a member of the banned German Catholic Peace Movement (*Friedensbund deutscher Katholiken*). When it became increasingly difficult for Jews in Germany, she traveled throughout the country, giving assistance to Jewish families wherever and whenever she could.

Even before the Nazis came to power in Germany in 1933 and before World War II and the Holocaust, Gertrud Luckner was ecumenical in mind and spirit. She had been raised as a Quaker, but she became a Catholic after hearing the Italian Catholic priest and politician Father Luigi Sturzo (1871–1959) "in a packed hall at the University of Birmingham in 1927."[4] For her, religion was about compassion, reaching out from one person to another, a favorite method of hers "with which she worked magic."[5] What mattered to her were human beings and their well-being. Her political views, influenced by

her Quaker upbringing and her Catholic social justice, contributed to her early identification of Hitler's political and international danger.[6]

After the outbreak of World War II in 1939, Luckner organized a special Office for Religious War Relief (*Kirchliche Kriegshilfsstelle*) within the Caritas organization, with the blessing and active support of Freiburg's Catholic Archbishop Conrad Gröber. Although the record of the institutional Christian Churches (Catholic and Protestant alike) in Germany during the Nazi era and the Holocaust is less than exemplary, there were individual church people – clergy and laity alike – who tried to help people persecuted by the Nazis. And while Archbishop Gröber was not what one would call an outstanding anti-Nazi resister, neither was he a rabid supporter of Hitler.

As the war wore on, the Office for War Relief became, in effect, the instrument of the Freiburg Catholics for helping racially persecuted "non-Aryans," both Jewish and Christian. As the driving force behind this relief effort, Gertrud Luckner used monies she received from the archbishop to smuggle Jews over the Swiss border to safety and to pass messages from the beleaguered German-Jewish community to the outside world.

Luckner often worked with Rabbi Leo Baeck,

the leader of the Reich Union of Jews in Germany (*Reichsvereinigung der Juden in Deutschland*), to help the Jews. She remained in close contact with him until his arrest and deportation to Theresienstadt in early 1943. Then, on November 5, 1943, as she was on her way by train to Berlin to transfer 5,000 marks to the last remaining Jews in that city, Luckner was arrested by the Gestapo. For nine weeks, she was mercilessly interrogated by the Gestapo, but she revealed nothing. She was then sent to Ravensbrück concentration camp for 19 harrowing months until she and thousands of other women were liberated by the Soviet army on May 3, 1945.

Asked why she did what she did, risking her life to help Jews and others who were in danger during the Nazi era and the Holocaust, almost astonished, she always replied that it "was obvious." What did she mean? Asked if it was "religious conviction" that prompted her to do what she did, she responded with one word: "Probably."[7]

After the war, Gertrud Luckner established a center for Catholic-Jewish reconciliation in Freiburg, although the mood in the country in the 1950s did not support such work, nor did the Vatican. However:

> Having risked her life for Jews and spent the last two years of the war in Ravensbruck concentration camp, Luckner found it impossible to abandon the remnant of Jewish humanity that survived the Holocaust. Already 45 years old at the war's end and in poor physical condition, the irrepressible Luckner decided to dedicate

herself anew to fighting German antisemitism and promoting Christian-Jewish reconciliation. Luckner knew such reconciliation would be a long-term process, simply because it meant confronting German and Christian antisemitism.[8]

Luckner established the Freiburg Circle, a German dialogue group devoted to conciliatory work with Jews, as well as a journal, the *Freiburger Roundbrief*, which, because of Luckner's personal credibility, attracted Jewish readers and correspondents of international reputation. Her friend Rabbi Leo Baeck, who survived the war and the Holocaust, never forgot that Gertrud Luckner was risking her life for Jews when she was arrested by the Gestapo. At his invitation, she visited Israel in 1951, one of the first Germans to do so. It was the first of several visits to Israel, where there is now a home for the aged named in her honor.

Dr. Gertrud Luckner devoted herself to the work of Christian-Jewish reconciliation after the war. In no small part, it was her persevering work as a Catholic that helped nudge the Church to begin to come to terms with its long and shameful history of theological anti-Judaism. While there were others – clergy and lay, women and men – who also helped the Catholic Church rethink its religious and practical relationship with living Jews and Judaism, few were more dedicated to this task than Gertrud Luckner. On February 15, 1966, Yad Vashem recognized Gertrud Luckner as Righteous Among the Nations.[9] ∎

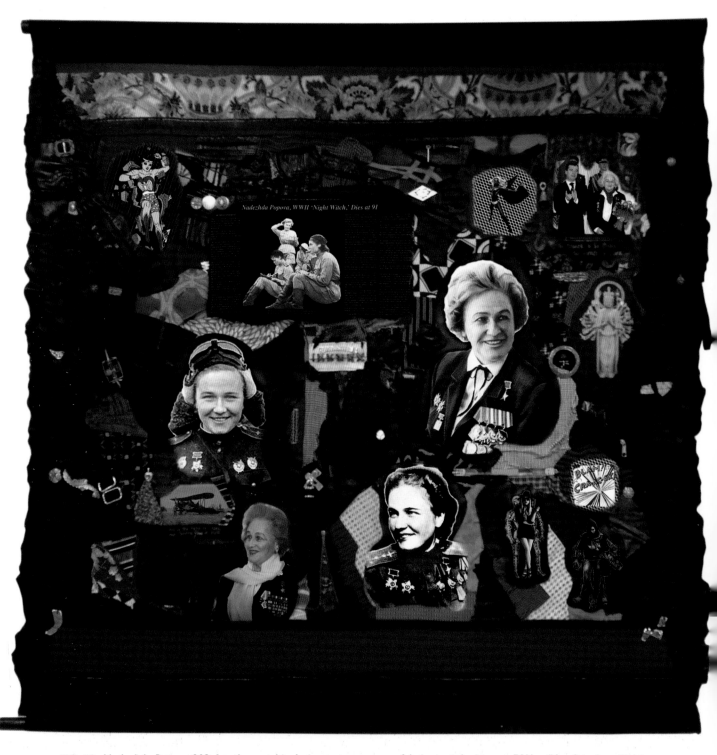

FIG. 25. *Nadezhda Popova 803*. Leather, archival pigment on canvas, fabric, metal, zippers; 58¼ x 59 x 2 inches; 2015.

Nadezhda Popova (1921–2013)

As one of the first female military pilots in the Soviet Union, Popova was highly decorated with awards including the title "Hero of the Soviet Union," the Gold Star Medal, the Order of Lenin, and three Orders of the Red Star. Born: Soviet Union. During Holocaust: Soviet Union.

NADEZHDA POPOVA
Hero of the Soviet Union

Molly Merryman

Nachthexen: A word that struck fear into the German invaders, who, as Nadezhda Popova said, came "like a terrible storm had invaded our country."[1] Nachthexen: Night witches. A term these women pilots initially disliked; a term they stopped hating when they understood the terror it represented in the minds and bodies of their invading enemy.

Nadezhda Popova was one the most decorated combat pilots of World War II, and she was a celebrated hero of her country, the Soviet Union. She was awarded the Hero of the Soviet Union, Gold Star, Order of Lenin and three times the Order of the Red Star.[2] Nadezhda's war was not a war of distant battles fought for liberty, justice and freedom. This was a bloodletting of brutal and epic proportions: millions of square miles of land viciously shredded as the German military pushed in as far as Stalingrad and Leningrad before being forced back, at least 20 million Soviets slaughtered or starved to death, tens of millions of Soviet prisoners of war and Jewish citizens deported to Nazi death camps, untold millions of girls and women raped, and countless numbers of homes, farms, factories and businesses destroyed by the wrath of war.

War was no abstraction to Nadezhda Popova or to her family. Her brother Leonid was killed in battle during the early days of the invasion. She wanted to avenge his death and sent a telegram to Moscow asking to be sent to the front, as she already was a trained pilot. This was not to be her only personal loss: The advancing Germans pushed into the Ukraine and occupied her village. She recounted later that her family home "became the fascist police office. They destroyed the apricot trees and the flowers and used our garage to torture our people."[3]

Operation Barbarossa, the German invasion of the Soviet Union, was even more brutal than Germany's conquests of Poland and France. It was the largest military operation of World War II, with more than three million German soldiers supported by another half million troops of Germany's allies attacking on a broad front. But the shock and the killing of the initial invaders was not the worst. As they advanced, they were followed by Einsatzgruppen (mobile killing units), that implemented mass-murder operations. For the Nazi invaders, the conquest of the Soviet Union was vastly different from operations in Western Europe. Nazi ideology regarded both Slavs and Jews as subhuman and considered Communism part of a larger Jewish conspiracy. This disdain for the Soviet people was

reflected not only in their brutal treatment of civilians but with their refusal to follow the Geneva Conventions for treatment of prisoners of war.

Out of the estimated 5.7 million Soviet soldiers captured by the Germans, 3.3 million were dead by the end of the war. In fact, in the overall scale of the Holocaust, Soviet prisoners of war (5 percent were Jewish) were second only to Jews as the largest group of victims of Nazi racial policy.[4] The Auschwitz-Birkenau and Majdanek extermination camps were originally constructed to imprison and murder Soviet prisoners of war, and Zyclon B gas was tested first on Soviet POWs in Auschwitz.[5]

In the swaths of the Soviet Union occupied by the Germans, the death squads committed efficient civilian genocide, utilizing the pathways and technologies the military had already developed for handling the POWs. One million of the 5,693,851 Jews murdered in the Holocaust were from the Soviet Union. The only country with larger death tolls was Poland, which lost three million people – 90 percent of its Jewish population.[6] The Soviet Union lost 36 percent of its Jewish population – a figure that would have been so much higher had there not been millions of fierce warriors like Nadezhda Vasilyevna Popova.

Nadezhda was not the only woman fighting for Mother Russia. More than 800,000 Soviet military women went directly to the front.[7] Like the men, the majority were in support positions, but more than 300,000 served in combat roles, including as snipers, tank crews and pilots with fighter and bomber units. During the war, three regiments of women combat pilots were created: two bomber and one fighter. In addition, other women military pilots flew transport missions and ferried planes, including planes that were provided by the United States as part of the Lend-Lease program. These Soviet pilots would pick up planes that were flown to Alaska by the Women Airforce Service Pilots of the United States.

Nadezhda was with the 588th Bomb Squadron, which flew its first mission in June of 1942. After petitioning Moscow for a combat position following the death of her brother, Nadezhda was delighted. But her elation ended after her first mission, during which another plane was destroyed, killing two of her friends. After dropping her bombs, she returned to her base: "I was ordered to fly another mission immediately," she told Russian Life magazine in 2003. "It was the best thing to keep me from thinking about it."[8] She described a later mission that was particularly devastating:

Nadezhda Popova, WWII 'Night Witch,' Dies at 91

It was near Krasnodar. The night before there had been so much shooting and now we knew where it was coming from. I flew first and did it in a cunning way: I gained more altitude and when closer to the target I swooped down. I let the bombs off straight into the ammunition dump and right there I was trapped by the claws of searchlights. I maneuvered and suddenly I saw them switch to another plane that flew after me. Enemy planes took off and shot it down, it caught fire and fell. That was one. Then I turned my head and saw a second plane go down in flames and then a third one lit up the sky like a falling torch. By the time I got back, four of our planes had perished with eight girls in them burned alive. My heart broke and there was a lump in my throat, tears in my eyes. What a nightmare, poor girls, my friends, only yesterday we had slept in the bunks together. . . . It was a tragedy.[9]

Over the four long years of the German invasion she lost more sisters and brothers in arms to the invaders, more friends and family and townspeople. This was relentless war.

The 588th flew only at night, and engaged in harassment bombings of German encampments, rear-area bases and supply depots. The biplanes they flew were small, capable only of carrying two bombs weighing less than a ton. But there were advantages to these small planes: They were slower than the stall speed of German Messerschmitt fighters, their wooden and fabric frames avoided radar detection, and when, on approach to their target, they would cut their engines back to idle, the small engines made such little sound that they would frequently surprise the German soldiers on the ground, who often reported hearing only a slight whoosh of the fabric frames before bombs exploded. The aim of these missions was to disrupt and demoralize the enemy, so the psychological impact of these night attacks made up for the small bomb loads. "The Germans hated being made to scatter by women, calling them Nachthexen. One German source said "they were precise, merciless and came from nowhere."[10]

Typically the 40 planes of the 588th would fly at least eight nightly missions. Because of their small bomb loads, their routine was to bomb the target, circle back to their unlit airbase, get rearmed and fly back, again and again and again. On one mission, Nadezhda flew 18 missions – even more notable when one considers that US bomb crews could rotate home after 25 missions. "Almost every time," Nadezhda once recalled, "we had to sail through a wall of enemy fire."[11] Even without the threat of enemy fire, flying the open-cockpit biplane was dangerous, and in the Russian winter, deadly.

When the wind was strong, it would toss the plane. In winter when you'd look out to see your target better, you got frostbite, our feet froze in our boots, but we carried on flying. If you give up, nothing is done and you are not a hero.[12] ■

FIG. 26. *Hadassah Bimko Rosensaft 810*. Leather, archival pigment on canvas, fabric, metal, zippers; 56½ x 58¼ x 2 inches; 2015.

Hadassah Bimko Rosensaft (1912–1997)

Because of her medical training, Rosensaft was assigned to work in what was called the Jewish Infirmary at Auschwitz-Birkenau, where she saved hundreds of Jewish women from the gas chambers. After liberation at the Bergen-Belsen concentration camp, she helped thousands of critically ill inmates to survive. Born: Poland. During Holocaust: Poland, Germany.

HADASSAH BIMKO ROSENSAFT
Saving Others

Menachem Z. Rosensaft

On September 21, 1945, a 33-year old Jewish woman took the stand at the first trial of Nazi war criminals accused of perpetrating what we now call the Holocaust. For two days, she bore witness against SS-Hauptsturmführer Josef Kramer, the commandant of Bergen-Belsen who had previously been the camp commandant at Birkenau, and against 31 other SS men and women, as well as 12 so-called kapos – inmates who had been assigned certain supervisory tasks – who had sadistically persecuted and tortured her and countless others.

Asked if she was of Polish nationality, my mother, Dr. Hadassah Rosensaft, then Ada Bimko, introduced herself to the British military tribunal sitting in Lüneburg, Germany, as "a Jewess from Poland." She then gave a detailed, often chilling account of the horrors to which the inmates of Birkenau and Bergen-Belsen had been subjected by the defendants.[1]

Alexander Easterman, who attended the Belsen Trial as an official observer of the World Jewish Congress, described my mother's "iron control" as she testified against her erstwhile tormentors. "Hers," Easterman wrote, "was the accusing finger of the Jewish people as she stood erect before the den of murderers glowering under dazzling arc lights, and pointed with outstretched finger as she identified each criminal in turn."[2]

My mother's testimony at Lüneburg was not her most important accomplishment by any means. S.J. Goldsmith, who first met my mother when he was a war correspondent covering the Belsen Trial, wrote about her that, "She not only suffered but also helped to alleviate the sufferings of others."[3]

When my mother, a dentist who had studied in medicine in France in the early 1930s, arrived at Birkenau with her family from their hometown of Sosnowiec in southern Poland on the night of August 3–4, 1943, her parents, husband and five-and-a-half-year-old son were sent directly into one of the gas chambers. Forced to wear prison clothes, her head shaved, and with the number 52406 tattooed on her arm, she felt utterly disoriented and deprived of her sense of self. "I always felt humiliated and ashamed," she wrote in her posthumously published memoir. "I hated sleeping in my clothes. I was ashamed to admit that I was hungry. I was ashamed to go to the bathroom and to be exposed half naked in front of so many other women. I was ashamed of the way I looked. I seldom

spoke."[4] But then a cathartic, almost surreal event occurred. "One morning, after the roll call," she recalled, "a torrential rain came down. We wanted to return to the barracks but instead were forced by the SS women to sit there for hours. As the rain fell down over our bodies, I realized that we were utterly helpless. Tears came to my eyes, the first ones since my arrival. When they mixed with the rain and I sat there sobbing, I found myself again."[5]

In October of 1943, Birkenau's chief medical officer, the notorious Josef Mengele, assigned my mother to work as a doctor in the camp's infirmary. There she was able to save the lives of fellow inmates by performing rudimentary surgery, camouflaging their wounds and sending them out on work detail in advance of selection by the SS for extermination.

In September 1944, Ruta Krakowiak, a young Jewish inmate from the Polish town of Tomaszów Mazowiecki, became seriously ill. Diagnosed with scarlet fever, she was taken to the Birkenau infirmary from which patients deemed too sick to work were sent to their death in one of the camp's gas chambers. One morning, even though she was still running a high fever, she recalled decades later, my mother, the inmate in charge of the infirmary, "took me aside and gave me clothes. She asked me to get dressed as fast as possible and to move quietly. She wanted me to join the few healthy inmates who were being transferred to

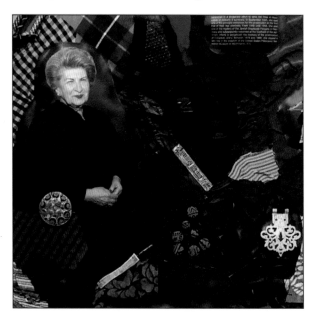

Birkenau. I was told not to ask any questions, not to say a word."[6] Ruta Krakowiak, who would become Ruth Fenton, did as she was told, and lived.

In November 1944, my mother was sent to the concentration camp of Bergen-Belsen in Germany where she and a small group of other Jewish women kept 149 Jewish children alive until that camp's liberation. This rescue operation began in December 1944 when they found 49 Dutch Jewish children outside their barrack and were ordered by the SS to take them in. These children became the core of what was called a Kinderheim, a children's home. They were soon joined by other children originally from Poland, Czechoslovakia and elsewhere.[7]

Hela Los Jafe, one of my mother's fellow inmates, recalled that, "Ada [my mother] walked from block to block, found the children, took them, lived with them, and took care of them."[8] According to Hela Los Jafe,

> The children were very small and sick, and we had to wash them, clothe them, calm them and feed them. . . . It was cold and terrible there, and the children cried because they were cold. Luckily they had Ada Bimko. Most of them were orphans, and she was like a mother to them . . . Most of them were sick with terrible indigestion, dysentery and diarrhea, and just lay on the bunks. . . . There was little food, but somehow Ada managed to get some special food and white bread from the Germans. . . . Later, there was typhus among the children. Ada was the one who could get injections, chocolate, pills and vitamins. I don't know how she did it. Although most of the children were sick, thanks to Ada nearly all of them survived.[9]

Keeping the children alive became a communal endeavor. "We sent word of the children to the Jewish men who worked in the SS food depot," my mother wrote, "and they risked their lives daily to steal food and pass it to us under the barbed wire."[10] Jewish prisoners in the Bergen-Belsen pharmacy smuggled over medicine for the children. My mother recalled that when the children desperately needed warm clothes during the harsh winter months of 1945,

> Somebody mentioned that there was a storage room in the camp where clothes taken away from the arriving inmates were kept. I went there

with two of the nurses. To my surprise I was greeted and hugged by two Polish women whom I had helped and protected from heavy work in the scabies block in Birkenau. They gave us all the clothes we wanted.[11]

In January 1945, Hetty Verolme was almost 15, old enough to be considered an adult by the Germans. The inmates of her barrack at Bergen-Belsen were being evacuated to another camp. In her memoir, she described how my mother, whom she called "the doctor," took her by the hand to ask the camp commandant to let her stay with the other children. "After he had scrutinized me," Hetty wrote, "he nodded his approval to the doctor and barked 'Los!' (Get going). Before he could change his mind, the doctor and I ran for our lives back to the children."[12]

Mala Tribich was 14 years old when she was deported to Bergen-Belsen from Ravensbrück, another concentration camp. In 2006, she told the BBC that Belsen in early 1945,

> was something beyond description. There was a terrible stench of burning flesh. The crematorium could not cope with all the bodies so they were burning them in pits. People were so emaciated, they looked like skeletons. They would be walking along and just drop dead. I heard there was a children's barracks. We found it and we were interviewed by two women – Dr. Bimko and Sister Luba [one of the nurses who had come to Belsen from Auschwitz with my mother]. They took us in. That was one of the things that saved my life, because I don't think we would have survived in the main camp.[13]

In 1981, my mother, who had been appointed to the United States Holocaust Memorial Council by President Jimmy Carter, chaired a session on medical rescue at an international conference on the liberation of the Nazi concentration camps. A survivor, Ray Kaner, took the floor to describe how she had been critically ill with typhoid at Bergen-Belsen in the winter of 1945. Her sister went to speak to my mother in the already overcrowded camp infirmary. Even though there was no room, Ray Kaner said, my mother had her brought to the infirmary and "Somehow, . . . my temperature dropped. I did survive the night." And then she said to my mother, "I looked for you for many years – 36 years."[14]

Within a few days of the liberation of Bergen-Belsen on April 15, 1945, Brigadier H. L. Glyn-Hughes, the Deputy Director of Medical Services of the British Army of the Rhine, appointed my mother to organize and head a group of doctors and nurses among the survivors to help care for the camp's thousands of critically ill inmates. For weeks on end, she and her team of 28 doctors and 620 other female and male volunteers, only a few of whom were trained nurses, worked round the clock with the military personnel to try to save the lives of as many of the survivors as possible. Despite their desperate efforts, the Holocaust claimed 13,944 additional victims at Bergen-Belsen during the two months following the liberation.

Lt. Colonel Mervyn Gonin, one of the British officers at Bergen-Belsen in April 1945, described my mother as "the bravest woman I have ever known, who worked miracles of care, kindness and healing with the help of no medicines but the voice and discipline of a Regimental Sergeant Major of the guards."[15]

Where my mother found the strength to help and take care of others rather than focusing on her own survival has always been a profound mystery to me. Perhaps, as S.J. Goldsmith wrote, "she saved herself by saving others."[16] ∎

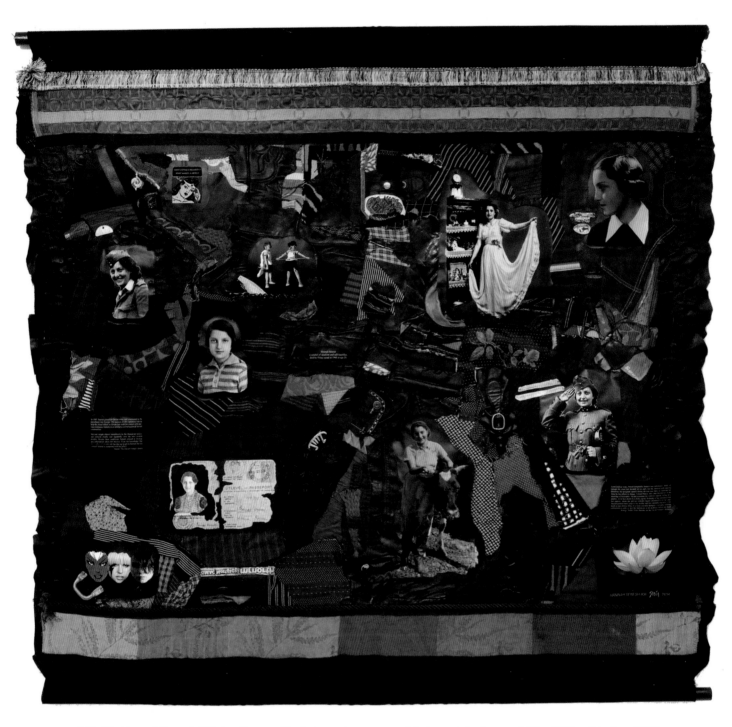

FIG. 27. *Hannah Senesh 806.* Leather, archival pigment on canvas, fabric, metal, zippers; 54½ x 58½ x 2 inches; 2015.

Hannah Senesh (1921–1944)

As one of 37 Jews from Mandatory Palestine parachuted by the British Army into Yugoslavia during the Second World War, Senesh assisted in the rescue of Hungarian Jews about to be deported to the German death camp at Auschwitz. She was apprehended and killed by the Nazis. Born: Hungary. During Holocaust: Palestine, Egypt, Yugoslavia, Hungary.

HANNAH SENESH
Stoic and Rebellious Poet

Marge Piercy

Hannah Senesh [or Szenes] was born into a comfortable and intellectual Jewish family in Budapest in 1921. Her diaries and the reminiscences of family members show her to be a bright but otherwise ordinary child of such a family. Her father, who died when she was six, and her mother, Catherine, were assimilated Jews with no interest in Zionism and little in religion. Hannah's first experience with anti-Semitism occurred in a Protestant high school that admitted Jews and Catholics, while charging three times as much for their tuition.

Hannah wanted to be a writer from an early age, as her father had been a well-known playwright. She was elected to the school's literary society but was excluded from being an officer because she was Jewish. Although she had high grades and was rated by the school as gifted, she could not go to university as Jews were forbidden. In the context of increasing laws and violence against her people, she became interested in Zionism, joining Maccabea, a Hungarian Zionist organization for young people. It was not a path common among her relatives or peers but viewed as strange and slightly uncouth.

In spite of a lack of comprehension on the part of her mother and brother, to whom she had always been close, she decided to immigrate to Palestine in 1939, a stubborn and lonely choice. No one in her family supported her plan. She made her way there and enrolled in the Girls' Agricultural School at Nahalal. Her diaries of the time reveal great self-searching both personal and religious and fears for her family back in Hungary as well as new friendships. She was neither conventionally religious nor conventionally secular. She was not at home in synagogue prayers but felt driven by what she identified as G–d.

She studied Hebrew passionately in order to become fluent, and Hebrew is the language in which she eventually wrote the few intense, direct and moving poems we have as part of her legacy. She traveled around the land, visiting various kibbutzim before settling after graduation in Sedot Yam. She chose a kibbutz where she would be forced to speak Hebrew, as opposed to one comprised of Hungarian Jews. At Sedot Yam she carried out all the ordinary tasks of working in the fields and in the kitchen and laundry, specializing in raising poultry. She committed fully but confided in her diary doubts about whether what she was doing was the best use of her abilities. She never stopped thinking about the situation of Jews back

in Europe. She did not pride herself on her smart choice of emigrating out of danger but rather brooded about what she could still do to help.

In 1941, she joined the Haganah, the paramilitary group that defended Jewish settlements against constant attacks. She was as much a soldier as any of the men. She became part of the Palmach, the more militant force within it. The Haganah was sometimes recognized and used by the colonial British powers that ruled the country and sometimes not, including unsuccessful efforts to disarm them from time to time. When the British White Paper set strict limits to Jewish immigration away from the Nazis, the Haganah brought in refugees illegally. But well into World War II, the British again approached the Haganah and set up Jewish brigades to fight in Africa. They saw that trained fighters could be useful to them.

In 1943, while the British were recruiting Palestinian Jews to fight for them, Hannah joined the Women's Auxiliary Air Force as an

Aircraftwoman 2nd class. After training as a wireless operator and then a paratrooper, she volunteered for a clandestine group who were to operate behind enemy lines in Europe. Her brother Grury by then had managed to get into Palestine and they had a very emotional reunion.

Here in Eretz Israel she was in safety. She had had the foresight to get out of Hungary while it was possible to do so. She had established a life in her new country that suited her. She had friends. She had work. She had begun to write strong poems in Hebrew. And she gave up the safety, the life she had created to go into danger and probable death, all in the hope of saving perhaps a few Jewish lives from the death camps. If that isn't heroism, I don't know what is.

In mid-March she and 16 other Palestinian Jews parachuted into Yugoslavia, as it existed then. Their official mission was to help downed British pilots to get out of Nazi-occupied countries. What Hannah aimed to do was to help Jews escape the Holocaust. While in Eretz Israel, she had begun to write those intense short and memorable poems that people find so moving today. She joined the partisans in Yugoslavia, waiting for a chance to enter Hungary. A poem she wrote in the partisan camp ends:

The voice called and I went.
I went because the voice called.

Shortly after she crossed the border with her radio into Hungary, now occupied by the German Army, she was captured. She was taken to a prison in her hometown of Budapest. There Hungarian authorities tortured her, hoping for details of British plans and wireless codes. She was stripped, tied to a chair and whipped and clubbed for three days, losing several teeth. She resisted torture and refused to give any information.

Her mother was being held in the same prison. They were brought together by the authorities so that the emotional shock (Catherine had thought her daughter was safe in Palestine) might loosen their lips, but even the sight of Hannah's battered condition and the threats of their captors did not sway either of them. The authorities threatened to kill Catherine if

Hannah did not give them the British wireless codes. She refused. She was dedicated to her mission and knew if she gave up the codes, others would be in danger. She would not let herself be responsible for anyone else being captured.

After that, Hannah and Catherine caught only accidental glimpses of each other. Hannah communicated with other prisoners using a mirror at the window of her cell and also by singing. She tried to keep up the spirits of those prisoners she could reach. Finally Catherine was released and tried to secure Hannah's freedom.

After six months in prison, in November of 1944, Hannah was tried as a spy and sentenced to death. She was 23. She wrote her last poem ending, in English translation: "The die was cast. I lost." Stoic and rebellious to the end, she faced a firing squad and refused a blindfold. She chose to look her German executioners in the eyes as they shot her to death.

Somehow her body was secretly carried to the martyrs' section of the Jewish Cemetery for burial. In 1950, her corpse was exhumed and brought to Israel and reburied in an honored place in the cemetery on Mt. Herzl in Jerusalem. Her mother survived the war and joined Gyury in Israel, where she lived out her life celebrating her daughter's work and life.

Where did Hannah's strength come from? She had passionate convictions and powerful empathy for those in danger. She could not stay in safety when others were being put to death for no reason other than being Jewish or part Jewish. She made herself a poet in Hebrew, not her native language. She made herself useful in manual labor and studied poultry diseases to better serve her kibbutz. She turned herself into a warrior, took up arms, studied combat and infiltration as she had studied literature and languages. She never asked for any exemptions or quarter for being a woman. Photos show her as attractive, but that never seemed important to her. She was a gifted poet who might have developed into a major writer, but again, that did not make her feel entitled to opt out of danger. She did not value her life In spite of her gifts, she did not value her life any higher than any other life. It was what she had to give and she gave it

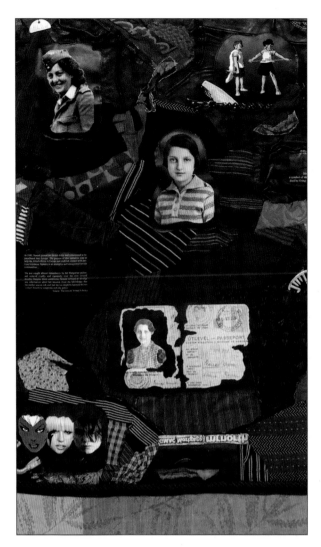

The British knew there was little chance any of these paratroopers would survive and I believe only one of them did. He left a powerful tribute to Hannah's bravery, leadership and charisma. The volunteers themselves knew the odds were far from in their favor. Yet they went. She went.

She gave herself utterly into what she considered the thing she was called upon to do, regardless of what it would cost her. That's why she is sometimes called the Jewish Joan of Arc. Like Joan, she was driven to fight for her people. Like Joan, she had a vision of how she could be effective. Like Joan, she died a hero for what she believed and even more, what she did.

Every year at Pesach when I lead our seder, when we light the candles I recite her poem "Blessed is the match consumed in kindling flame." And I remember her heroism and honor her. ∎

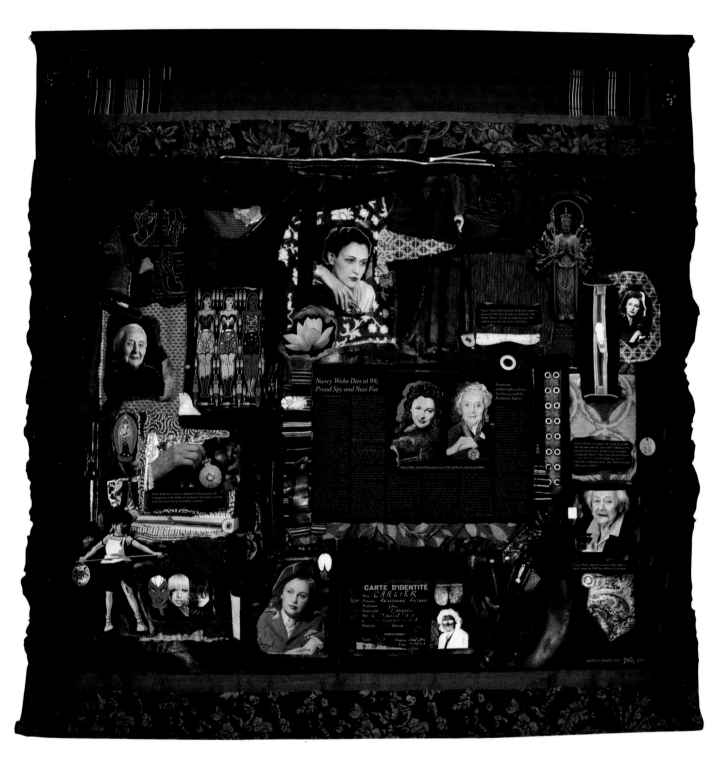

FIG. 28. *Nancy Wake 802*. Leather, archival pigment on canvas, fabric, metal, zippers; 58 x 58 x 2 inches; 2015.

Nancy Wake (1912–2011)

After the fall of France in 1940, Wake became a courier for several escape networks. Then, serving as an agent of the British Special Operations Executive (SOE) she became a leading figure in the maquis groups of the French resistance and was one of the Allies' most decorated service women of the war. Born: New Zealand, lived in Australia. During Holocaust: France.

NANCY WAKE
The Feminine/Masculine "White Mouse"

Kathryn J. Atwood

Many combatants and resisters, attempting to defeat the brutal Axis Powers during World War II, privately feared the irrevocable alteration of their personalities. Nancy Wake, a fierce combatant against the Nazi regime, shared this concern. That she succeeded in retaining her multi-faceted persona not only attests to her strength of character but, at one point, proved invaluable in her battle against the Nazis.

Born in New Zealand, Nancy Wake's resistance work began shortly after France was defeated, and only months after her marriage to the wealthy Marseille industrialist Henri Fiocca. Shortages caused by the German occupation placed a crimp on her pre-war lifestyle, but the gregarious Nancy socialized nearly as much after the June 1940 invasion; only now she exercised more caution. The German occupation created an edgy split in French society, more gaping than the nation's sharp pre-war political divide. Everyone fell into three general categories: some, following the lead of Philippe Pétain – the World War I hero who headed the French collaborationist government at Vichy – became eager collaborators with the Germans. Others remained cautiously neutral, watching, waiting, and surviving. Still others would bring an unequivocal new meaning to an old word: Resistance.

"For me," Nancy Wake said, years later, "there was never the slightest question of collaborating with the Germans. I had seen what they had done in Vienna and Berlin . . . I wanted to have nothing to do with anything other than trying to stop them."[1]

What she had seen in Vienna and Berlin was the horrific reality of second-hand reports. In 1933, while working in Paris as a journalist, Nancy met several German intellectuals in the bistros she frequented with her large circle of friends. One of them explained Paris's sudden flood of mostly Jewish-German refugees as the work of Adolph Hitler, head of the Nazi party and Germany's new leader. Horrible, unbelievable things were happening in Austria and Germany.

Not content to form an opinion based on someone's word, Nancy joined some of her fellow-journalists on a trip to Vienna and Berlin in 1934. In Vienna's main square, she witnessed Jewish men chained to enormous wheels. Pushing the wheels and whipping the chained men were Hitler's SA squads, the infamous Storm Troopers, the Brownshirts. In

Berlin she saw more brutal anti-Semitic activity: Brownshirts whipping Jewish shopkeepers and destroying the contents of their shops in bonfires.

These images determined Nancy's guiding principle for the next decade: "I resolved there and then that if I ever had the chance, I would do anything, however big or small, stupid or dangerous, to try and make things more difficult for their rotten party."[2]

She took a brief, active role during the Battle of France driving an ambulance. But more dangerous than coming under enemy fire was what she did shortly after France's fall to Germany. She accepted a risky mission from a relative stranger. While socializing in Marseille, Nancy and her husband met a French Army officer named Busch. They realized he was involved with the resistance, and when he learned that they were traveling to Cannes, he asked if they would carry an envelope there for him. Nancy didn't know what the envelope contained but she knew the implications of accepting a mission from someone involved in the resistance. If caught, she would certainly be questioned, possibly imprisoned or worse. She accepted the mission without hesitation. It may have been "small, stupid or dangerous" but she saw it as her chance to work against the Nazis.

The envelope led to subsequent work and Nancy soon became a regular courier for several escape lines geared towards rescuing Allied soldiers trapped in France. The oft-solitary inactivity intrinsic to courier work – waiting, waiting, and more waiting – grated on this woman whose pre-war joie de vivre lifestyle had been filled with socializing and drinking. She longed for action. "I used to wish I could meet someone who would give me a less boring task," she wrote later. "I was at the stage when I longed to do something really constructive against our enemy."[3] But she endured the tedium. She knew that each package she delivered, every serviceman she helped escape would throw a wrench, no matter how small, into the Nazi war machine. And her success as a courier of packages and men forced her into a new opportunity, the active resistance she longed for.

The Gestapo issued a 5-million-franc award for the "White Mouse," the woman helping Allied

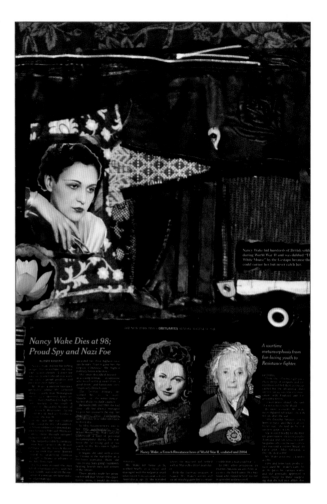

Nancy Wake had hundreds of British soldiers during World War II and was dubbed "The White Mouse" by the Gestapo because she could corner her but never catch her.

Nancy Wake Dies at 98; Proud Spy and Nazi Foe

A wartime metamorphosis from fun-loving youth to Resistance fighter.

Nancy Wake, a French Resistance hero of World War II, undated and 2004.

servicemen escape occupied France, who, like a quick little rodent, kept evading their grasp. When Nancy's phone line was tapped and her mail opened, she knew the Gestapo was closing in. She bade farewell to her Marseille life and escaped.

After an arduous, lengthy journey, Nancy arrived in London where she soon attracted the notice of the Special Operations Executive (SOE), the British wartime organization designed to foster resistance from within Nazi-occupied countries. Along with two male agents, Nancy was trained to work with the maquis, guerilla fighters who had escaped forced labor in Germany and banded together in the woods of southern France to fight the Germans. The SOE strategy was to organize them for the approaching D-Day invasion of occupied France. The thousands of maquisards who eventually found themselves in Nancy's orbit were eager to fight the Germans but needed her help.

How could this pretty woman convince these

hardened men, raised in France's patriarchal society, that she was their equal and deserved their respect? Instead of cursing the darkness of their male chauvinism, Nancy, in a manner of speaking, lit a candle. And poured a drink. Her former partying skills now proved useful. "Whenever I visited a new maquis group and was invited to drink with them," she wrote later, "I always accepted and made a point of going drink for drink with the leader."[4] She drank the men under the table every time. Or, the bushes, in this case, as they were all living together out of doors. She was accepted as one of them.

But was she becoming one of them? A female German spy was discovered in the woods. Nancy ordered her execution. As the young woman walked to her death, she spat at Nancy and screamed "Heil Hitler!" with her final breath. The fact that Nancy felt no pity unnerved her. "How had I become so aggressive?" she wrote.[5] The answer wasn't necessarily the constant presence of men. It was also German brutality. She had recently witnessed a German reprisal against French resistance: a pregnant woman tied to a stake, bayoneted, and left to die in front of her screaming two year old. "The enemy had made me tough," she explained. "I had no pity for them."[6] She could never muster sympathy for anyone loyal to Hitler when, always, she wrote, "I remembered Vienna, Berlin, and the Jews."[7]

If lacking pity for a brutal enemy was mannish, so be it. But Nancy was determined to retain a vestige of her femininity. "No matter how tired I was, after a day in the male world wearing trousers," she wrote later, "I'd change into a frilly nightie to sleep."[8] And whenever an ammunitions drop arrived from London, it always included a small package for Nancy consisting of tea, makeup and perfume. She clung to these treasures.

She sometimes clung to them quite tightly, waging her own private war against encroaching masculinity. In June 1944, immediately after D-Day, the Germans launched a major attack against the maquis in her area. As she drove away in the mass exodus, a German plane broke formation and singled her out. After outwitting the strafing pilot by suddenly braking, Nancy ran out of the car and into the woods with another maquisard. The German pilot turned around

and was heading back, seemingly determined to destroy the empty car. Suddenly Nancy rushed out of the woods, beat the pilot to the car, grabbed something out of the back seat, then raced back to the woods just before the car exploded. "Forgot these,"[9] she explained to her dumbstruck companion. She had rescued a saucepan, a jar of face cream, some tea and a red satin cushion.

If her affinity for feminine things nearly cost Nancy her life in this instance, it would soon save the work of all the maquis in her area. During the retreat, Nancy's panicked radio operator had buried his radio. The surviving maquisards were regrouping for another fight but without London radio contact, there could be no ammunitions drops, no further fighting. The only solution was for someone to bicycle hundreds of kilometers through German controlled territory to the nearest radio operator. It was out of the question for any of the men to attempt it. Their gender would immediately give them away. This was a job for a woman. A womanly woman.

Nancy obtained suitable clothes. Then she hopped on a bike and demurred her way past unavoidable checkpoints, smiling at every German she encountered while cursing them under her breath.

Her 72-hour journey totaled 500 kilometers. She couldn't move for days afterwards. But a new radio was dropped, and contact with London reestablished. The fight against the Germans continued and Nancy's personal battle to retain her femininity was more than justified.

Which aspect of this woman's persona made her one of the most highly decorated women of World War II? Was it the drinker and fighter who would later lob grenades into a room full of German officers and kill a German sentry with her bare hands? Or was it the woman who slept in a frilly nightgown, risked her life for face cream and a satin pillow, and easily passed for a pretty French housewife during her indispensable bike ride? It was both. Nancy Wake used everything in her arsenal – her beauty, her tolerance for alcohol, and her willingness to take a life . . . or a bike ride – to fight the regime whose virulent anti-Semitism had aroused within her a fierce determination to wage war. ■

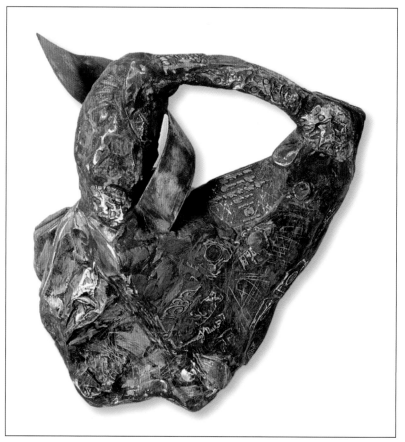

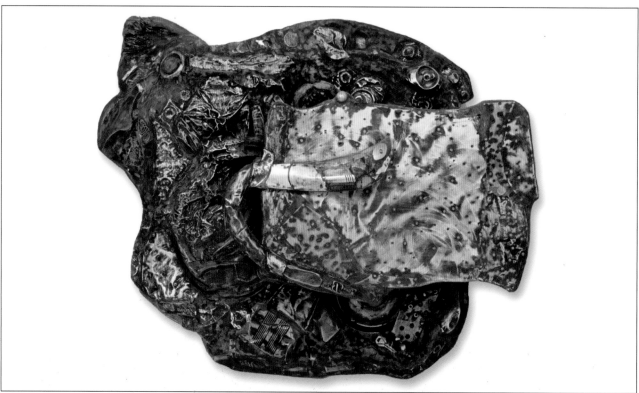

FIG. 29. Top left: *Two Women Standing 322*. Wood, stone, metal; 37 x 24 x 16 inches; 1999. Collection of Richard and Carole Siemens. Top right: *Soft Curve 312*. Wood, stone, metal; 19 x 18 x 8 inches; 1998. Collection of Will Barnet. Bottom: *Overlay Double Shield 219*. Wood, metal, stone; 32 x 38 x 8 inches; 1994.

Linda Stein's Holocaust Heroes: Fierce Females *and Related Works*

Gail Levin

Linda Stein's *Holocaust Heroes: Fierce Females* is a remarkable series of large hanging collages on fabric that she calls "tapestries." Though these pictorial works are assembled and then sewn together, they are made to hang on the wall as a tapestry does. Still, they are technically more like appliqués than woven tapestries. They are actually constructed, not woven, except in a metaphorical sense. It is true that Stein "weaves" a story about each of the women who is the subject of one of these works. In *The Iliad,* Homer describes Helen as weaving the story of the sufferings of the Greeks and the Trojans. In that sense, Stein has created "woven tapestries."

Stein has gathered published research about each of the women to whom she dedicates a work. She has chosen these women by asking, "What makes a hero?" "What defines bravery?" She then searches for multiple photographic images for each of her subjects and combines these with found texts that she either quotes directly or paraphrases. She also adds other pertinent images from history and figures from popular culture. Stein employs varied materials, contrasting textures, patterns, and colors. For example, she juxtaposes diverse printed fabrics recalling calico cotton against the dramatic starkness of black leather. She sets up a huge contrast of the seemingly light-hearted and homey prints with the weight and density of black leather that carries with it multiple associations ranging from powerful, sensory, and erotic to the toughness of biker culture.

For good measure and visual interest, Stein also incorporates disparate three-dimensional items – from zippers and buckles to handles. She has even included metal elements left over from the calligraphy business she once owned. In this sense she rescues her past and gives it new life. Her recycling of these old pieces of metal recalls the painter Lee Krasner cutting up rejected drawings left over from her days as a student in the Hofmann School and putting the fragments to new use in collages that she made decades later.[1]

Yet, in contrast to artists like Krasner and Hofmann, who worked abstractly, Stein now creates tapestries with a specific mission and a social message. Like certain performing artists, from Lady Gaga[2] to the Canadian musicians who in 2012 banded together as *True Colors,* Stein campaigns against bullying anywhere. She also celebrates others who tried

to protect the vulnerable, even in the impossible setting of the Nazi regime during World War II. Stein admires Lady Gaga's activist stand against bullies and thus her image is one that recurs in these tapestries.

Stein wants us to know about heroic women during the time of the Holocaust, who are, she points out, less recognized than their male counterparts. She wants to encourage everyone to stand up for those who cannot defend themselves. She intends for these works to educate and to motivate their audiences.

Thus, Stein works in the tradition of American Social Realists of the 1930s, who identified with the downtrodden and the needy and made works that were in a sense a call to action. I am thinking of particular work by artists like the photographers Dorothea Lange, Berenice Abbott, or Lewis Hine, or painters like William Gropper or Ben Shahn. While Lange, through her photographs, for example, brought to public attention the plight of the poor during the Great Depression, Stein updates this kind of social vision through her concern for the victims of bullies and for gender equality. She has become committed to being an activist as well as an artist.

Not content just to exhibit her artwork, Stein also engages in performance to get her message across. But message, she does convey. She founded the non-profit corporation, Have Art: Will Travel! (HAWT). In the Jewish tradition of *Tikun Olam*, "to make the world a better place," Stein tours her art with a missionary zeal to stop injustice.[3] Her sincerity and dedication to her cause pervade her art work. The tapestries are the result of years of researching this topic and then designing and making what she imagines as the most effective vehicle to convey her message. To do this, her creations have to be easily portable (to travel) and they have to speak directly to her diverse audiences.

A contemporary feminist exhibition project on the Holocaust has art historical precursors. For example, Judy Chicago collaborated with her husband, the photographer Donald Woodman, on a touring exhibition called *The Holocaust Project: From Darkness into Light,* which was first exhibited in 1993.[4] Those monumental works were made of diverse materials and employed varied techniques – from actual tapestries (designed by Chicago, but woven by her collaborator, Audrey Cowan), to photographs by Woodman, to fabricated stained glass. While Chicago's project told of her own personal discovery and study of events that had taken place during the Holocaust, Stein has chosen a different emphasis – the stories of individual heroic women. Few of Stein's subjects appear to have received much attention, especially from visual artists. Stein says that she identifies with each woman as she makes her visual account of that woman's experience.

Beyond feminist art, Stein's aesthetics reflect other influences – from her visit with Robert Rauschenberg in Captiva Island, Florida, over Christmas week in 1983[5] – to the work she once did in calligraphic engraving and printing to earn her living. Her previous production had to be both visually attractive and able to communicate its message, skills that serve her well now. As for Rauschenberg's influence, however, we can perhaps see it in Stein's creation of "body-swapping armor" and other life-size figures. She has designed transformative avatars just as Rauschenberg once made costumes for performances in modern dance choreographed by Merce Cunningham, Paul Taylor, and others. But, unlike Rauschenberg, Stein continues to inspire and motivate her participants before each performance.

We can perhaps also identify in Stein's current tapestries the delayed influence of Rauschenberg's use of multiple vignettes arranged on textiles. Stein responded to Rauschenberg's habit of breaking down the boundaries between painting and sculpture in his *Combines* and to his penchant for using both traditional art materials and ordinary objects such as clothing and urban debris. Stein not only incorporates such scraps in her tapestries, but she also actually designs clothing, protective "bully-proof vests," that she sells as art works to wear.

After Stein chooses her fragments of fabric, leather, wood, and metal, she attaches them to a flat soft support material that can be rolled up. She also incorporates multiple photographs of the heroic women in question into the soft background. In a sense, Stein's "tapestries,"

while suppressing the decorative, can also be linked to the tradition of quilting in its best narrative aspect. Quilts, once dismissed as "woman's work," became an important source of inspiration for feminist artists during the last quarter of the twentieth century.

In refusing to be decorative, Stein rejects the geometric repetition and colorful components of so many traditional patterned patchwork quilts, usually made by women. Yet, she instead seizes the opportunity to tell the heroic stories of these women who were caught in the Holocaust. Determined to share their stories, Stein makes them into visual icons to convey her message of what she believes they tried to accomplish.

Stein repeats the image of each of her subjects across her tapestry. In this sense, her works function like a predella on a Renaissance altarpiece, a comic book or a graphic novel, as distinct frames in a continuous film, or even like Asian handscroll paintings, where the characters reappear as the narrative unfolds horizontally across both literal and symbolic time and space. Many handscrolls also contain written commentary that accompanies the images.

We can see Stein's tapestries in the same context as the work of other socially active contemporary artists who work in textiles. Prominent in this area is the feminist activist Faith Ringgold, who tells her own narratives of African-Americans on what she calls painted Story Quilts. Buddhist *Thangkas* from Tibet or Nepal inspired Ringgold, who was drawn to these pictures painted on fabric and quilted or brocaded so that they could be easily rolled up and transported.

Stein, too, sought the advantage of portability, but she was drawn to Japanese Buddhist scroll paintings rather than to Buddhist *Thangkas* from Tibet or Nepal. Such vertical scroll paintings suggested to Stein the model for hanging her tapestries on rods just as the horizontal handscrolls offered scenes with characters repeated across time. On the several trips Stein has made to Japan, (often in the company of her spouse, Helen Hardacre, a scholar of Japanese religions and society),[6] she has found not only traditional materials, but also suggestive content that lends itself to her own message.

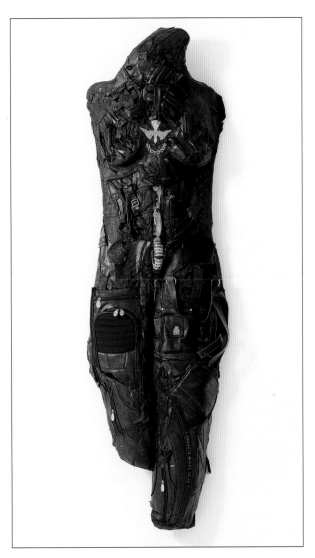

FIG. 30. *Protector 844.* Leather, metal, mixed media; 78 x 24 x 8 inches; 2015. Collection of Melva Bucksbaum and Raymond Learsy.

Stein's earlier series of protection figures recalls the monumental Japanese figures called Kon*gorikishi* or *Nio* that stand guard outside Buddhist temples. The form of these monumental figures is to cause fright, implying that they will call upon physical force to protect against evil, present even within the pacifist tradition of Buddhism. One from Stein's series, *Knights of Protection*, accompanies the tapestries and *Spoon to Shell* sculpture in this exhibition. For the tour, she chose the monumental *knight, Protector 841 with Wonder Woman Shadow* (2014). The shadow shows Wonder Woman, not violent, but waiting to defend and protect as needed.

Stein employs the motif of Wonder Woman, not only with *Protector 841,* but also in all of her tapestries. Stein's content is not just historical, for she can be at once serious and playful. The seed for incorporating images from comic books may have been planted on that same trip to visit Rauschenberg in Captiva, where Stein met and played tennis with his friend and neighbor, the Pop artist Roy Lichtenstein. She likes to tell that it was then and there that she finally gave herself permission to beat a man in an athletic contest and how she won their set. But perhaps, more useful, years later, she began to follow Lichtenstein's example in referring to comic book imagery, a practice that he had begun in 1961. In her case, however, she chose an early feminist icon: Wonder Woman.

In 1972, Wonder Woman, the comic book superhero introduced thirty years earlier, reappeared on the cover of the first regular issue of *Ms.* magazine, linking 1970s feminists with the Wonder Woman of their 1940s childhoods. "Looking back now at these Wonder Woman stories from the '40s," editor Gloria Steinem wrote, "I am amazed by the strength of their feminist message."[7] Stein, who as a child had herself identified with Wonder Woman's heroics, chose this comic book character along with several other characters from pop culture to stand in as symbols for the actions of her *Holocaust Heroes: Fierce Females.* She uses such recognizable references as unexpected exclamation points to raise the awareness of her audience. She says that the Pop culture icons that she includes are "talking points" for her performances.

Wonder Woman is not the only pop hero that Stein turns to over and over again. There is the superhero, Storm, from *X-men* comics with her superhuman and compassionate qualities, and Lisbeth Salander from the novel, then film, *The Girl with the Dragon Tattoo,* a character created by Swedish author Stieg Larsson.[8] Lisbeth Salander survived rape and a traumatic childhood, and is especially hostile to men who preyed upon and abused women, taking satisfaction in stopping their violence.

Stein also loves to include references to the iconic Princess Mononoke, from a very popular Japanese anime film of 1997, released in the United States in 1999. Stein seems to have identified with Princess Mononoke's bravery. Raised by wolf-gods, Princess Mononoke is said to be fearless in her desire to save the environment. She is said to be as strong as a force of nature.

Another of Stein's favorite images that recurs in her tapestries is Kannon, the Japanese name for the East Asian Buddhist deity of mercy, associated with compassion and saving people. Kannon, who hears the prayers of the world, is known by other names in different cultures, for example, as Guan-yin in China. Stein's source for this image, however, is Japan.[9] She is partial to the depictions of this figure that show the deity as having many arms. Such an image of Kannon appears, for example, in the upper right corner of the tapestry dedicated to *Nancy Wake* (2013), a leading figure in the French Resistance.

Ultimately, Stein's work engages with activism and cannot be separated from its moral purpose. Once abstract, she has now found herself engaged with narrative in her tapestries, combining research with a reformer's zeal. Though, once Stein assembles her constellation of images, she still constructs her compositions as if she were working abstractly.

Stein's earlier preference for abstraction inspired her to make twenty *Spoon to Shell* sculptures, which are variations on a Holocaust theme, each with a spoon, encased in a box and containing shells, which she sees as nature's protective shelters. While researching for her series of tapestries, Stein came across the story of one woman's report of the sexual privileges demanded in concentration camps in exchange for a spoon, which was felt to be necessary to avoid exposure to contagious disease while forced to eat from a communal food vessel.[10] Stein could not get the image out of her mind. Instead, she produced twenty sculptures, which are all variations on this theme.

In her *Protector* figures, the stories she tells in her tapestries, and through her *Spoon to Shell* sculpture, Stein has the goal to encourage her viewers to become "Upstanders," not bystanders. She is inspiring them to join in the fight for social justice. She is leading the way. ∎

Curricular Encounters with Linda Stein's Holocaust Heroes: Fierce Females

Karen Keifer-Boyd, Cheri Ehrlich,
Ann Holt, Wanda B. Knight, Yen-Ju Lin,
Adetty Pérez de Miles, Leslie Sotomayor

Encounters with art are pedagogical. This essay introduces curricular encounters with *Holocaust Heroes: Fierce Females – Tapestries and Sculpture by Linda Stein.*[1] The purpose of curricular encounters with Stein's work is to (re)imagine what global citizenship can be, and to highlight the role of art and education toward social justice.

Linda Stein began *Holocaust Heroes: Fierce Females* (H2F2), in 2011, after reading an obituary in *The New York Times,* "Nancy Wake, Proud Spy and Nazi Foe, Dies at 98."[2] Stein's drive to create art is based upon a deep concern for the well-being of all, an ethics of affirmation, and a desire to protect and be protected from all forms of violence – emotional, physical, institutional, environmental, and systemic. Stein's tapestries and sculpture are both visual and visceral narratives of identity, leadership, and social justice.[3] The art in the H2F2 exhibition calls for people to be *upstanders.*[4] An upstander joins with others, or stands alone, to protect others from violent circumstances in everyday experiences, such as bullying.

A team of art curriculum scholars and practitioners – with expertise in kindergarten through higher education teaching, museum education, information communication technologies, and social justice curriculum – have developed curricular encounters with the art in the H2F2 exhibition. Curriculum is not static, but changes with questions of knowledge: For whom? When is it true? Where is it situated? The online generative living curriculum for the H2F2 exhibition addresses the Social Justice Research Agenda set forth by the 2014 National Art Education Association Research Commission. The Commission's agenda is to "prepare art educators to respect and teach content based on social justice [and] promote understandings of diversity with regard to sexual orientation, cultural identity, religious beliefs, and other areas where prejudice and marginalization may exist."[5] Those who do not have access to seeing the actual exhibition will be able to view the work in a virtual gallery space, in which the art can be seen close up and from different angles.[6] When encountering the art online, questions, prompts, and intertextual materials appear as pop-ups. The prompts focus on upstander identity, leadership, and social justice. The purpose of the *H2F2 Encounters* website is to facilitate agency, empowerment, and reflection.

H2F2 curricular encounters are designed to be encounters with specific works or with a series of works in the H2F2 exhibition. Each

FIG. 31. Anne Frank tapestry Encounters website image with prompt: "Our many Jewish friends and acquaintances are being taken away in droves (Anne Frank, October 9, 1942) / How could the past inform the present, so that people could be welcomed home?"

encounter begins with looking at, discussing and experiencing Stein's tapestries and sculpture. These interactions may involve making art, or other sensory processes, as a way to engage with Stein's art in relation to self as situated in current social, political, and environmental contexts. Encounters with the H2F2 exhibition, presented in this essay and at the Encounters website, provide experiences that extend from, and then return to, Linda Stein's art.

Encounters with H2F2 offer ways to examine cultural-historical roots of social and environmental degradation, and to motivate upstander actions in (re)making community. Several encounters investigate visual culture as a means of communicating and perpetuating cultural values. Other encounters explore the ways in which visual culture affects perceptions of self and the world, and constructs power and privilege. The encounters are processes to analyze media, advertisements, photographs, alternative media, objects, spaces, places, signs and codes as sources of power, as well as to de/en/re/code dominant cultural narratives.

Underlying all encounters is the concept of *teaching toward understanding the value of diversity* (e.g., culture, ethnicity, religion, race, gender, sexuality, and ability) and understanding that everyone is responsible for the well-being of others.[7] The following are ways to encounter the H2F2 tapestries and sculpture as catalysts toward social justice education.

Identity is formed and maintained through the meanings of cultural artifacts. After viewing the short video of Linda Stein's *Holocaust Heroes: Fierce Females*[8] and, in particular, the *Spoon to Shell* series, identify a significant cultural artifact and consider contemporary meanings encoded in this cultural artifact. For example, a seashell is a protective outer layer created by an animal that lives in the sea. A shell can have various meanings. It can be a home, a dish, a spoon, a cutting or polishing tool, body adornment, an exoskeleton, or a source of protection. From where do the meanings associated with the cultural artifact arise?

For Stein, in her *Spoon to Shell* series, the narrative of a woman's experience being offered a spoon for sexual favors moved Stein to explore the spoon as a cultural artifact. When the only food substance is watery gruel in a bowl shared with many others, a spoon is a survival tool. Such was the case for people forced into concentration camps who feared transmission of tuberculosis, typhoid, and other diseases when placing their lips on the brim of a shared bowl. In refusing the spoon, offered by the man in return for sexual favors, the woman's life was in danger as the man doing the offering held power over her fate to live or die. Stein asks: *What would you do in such a situation? How do you keep your self-respect and survive?*[9] Agency can be a form of resistance or an act of opposition to force or power. Acts of agency and resistance may be subversive or obedient, overt or covert, or individual or collective.

The *Identity Exploration with Cultural Artifacts* encounter, with the *Spoon to Shell* series, begins with a discussion, while looking at the art, with others whose social class, age, gender, sexuality, and ethnic background differs from one's own.[10] To interpret a cultural artifact, it is important

to look at conditions for its production as they relate to socio-economic class structures, gender-role expectations, and specific visual codes of the time, as well as how those codes have changed over time. Using *Regender*,[11] read articles that are regendered – about the cultural artifacts – to discern whether and how the meaning has changed. Look again at each work in the *Spoon to Shell* series. What does the spoon signify in relation to the shells and text fragments and other items in this box assemblage (fig. 32)? The uniformity of the twenty black wooden, box sculptures brings order and calm to the chaos, fragments, and tensions that are visible from the window of each box. Stein uses spoons and shells as metaphors for power and vulnerability. Select a cultural artifact. Juxtapose it amongst other objects within a box sculpture. Investigate these cultural artifacts from a rhizome of associations and memories in an exploration of power, privilege, oppression, bigotry, leadership, and identity.

Tapestries Encounters Honor Heroes Around/Within Us

Feminist leaders recognize that some groups suffer disadvantages as a consequence of their gender, race, class, language, age, sexuality, religion, nationality, or ability. Stein's tapestries concern heroes who challenge and change evil/violent/power-making conditions and circumstances to realize a just and compassionate world. The heroes honored in each of the 10 tapestries saved lives and risked their own lives to do so. The purpose of several of the curricular encounters with Stein's tapestries is to learn about acts of agency and resistance by women who stood up for change during the WWII Holocaust. Each person honored by Linda's Stein's tapestries is a hero and, by extension, is a leader and a role model. Leadership can be everyday actions or passionate activism that advances social justice.

Stein's tapestries draw attention to fragments of life, using collage as a way to juxtapose, overlap, layer, hide, and reveal relationships. In a close view of the tapestries, for example, what meanings are possible when considering the juxtaposition of calico cotton next to black leather? Both could be fragments from aprons that, when placed together, suggest different kinds of service work that women have performed, including domestic work and sex-work. Look closely at each element and consider all of the possible meanings. Next, consider how each meaning is developed in relationship to other elements in the tapestry.

From reading the essays in this book and looking at the *H2F2* tapestries, one can learn about the lives and actions of the women, and the context of their lives. *The Hero Around/Within Us* encounter with H2F2 tapestries is a catalyst to create a collage honoring a woman who has made courageous decisions toward furthering social justice.

Wonder Woman Protector Sculpture and Tapestries Encounters: Justice and Upstander Narratives

Women, transgender people, ethnic groups, people with (dis)abilities, and children have continually been subject to the violent and unjust realities of sexism, racism, ableism, homophobia, and patriarchy. Social justice is first and foremost about

FIG. 32. *Spoon to Shell* series Encounters website image with prompt. "What does the spoon signify in relation to the shells and text fragments and other items in this box assemblage?"

changing inequities and marginalization. An encounter, called *Welcome Home,*[12] uses the Anne Frank tapestry and begins with reading excerpts from her diary, along with current news reports concerning groups of people seeking safety in a foreign land.[13] The current news could be juxtaposed with film images from *Voyage of the Damned,* a film, based on the 1939 true story of the *S.S. St. Louis,* a ship with many Jewish passengers, traveling from Germany to Cuba. The Jews were refused entry to Cuba and then by the US, when the captain subsequently tried to land in Florida. Forced to return to Germany, some passengers chose suicide over the inevitable concentration camps. Finally, passengers received news of shared asylum granted by Belgium, France, The Netherlands, and the United Kingdom.[14] Without this end, Hitler's genocide would only have been justified by the anti-Semitism existing beyond his borders. How could the past inform the present, so that people could be welcomed home (fig. 31)? Create a collage, which includes news images from the past and present, along with diary entries, that brings a personal perspective to current and historical events about the desire to be welcomed home. Seeking and learning about a diverse range of life narratives prompts an empathetic process of understanding injustice within the complexities of environments and communities.

Guided by the interactive prompts overlaid on the digitized tapestries on the Encounters website, explore Stein's use of feminist pop culture and religious icons such as Wonder Woman, Kannon, and Mononoke – who personify the values of empowerment, strength, justice, and protection. In this H2F2 encounter, answer the following questions: *Who are upstanders? What can I learn from upstander role models and their actions? What can I do, personally, to be an upstander on an everyday basis?* An encounter with H2F2, called *Upstander Narratives,* involves creating a graphic novel/cartoon that incorporates self-narratives of real and/or imagined experiences. What if each of Stein's fierce feminist leaders simultaneously had a prominent seat at the table on the national and world stage? What if all stood up when they were told to sit down? What if all spoke out,

when they were told to be quiet? What if . . . ? Further, identify and reflect on people who have demonstrated actions of protection, equality, and justice. Imagine the heroes and icons in Stein's artwork as animated and conversant life guides, shamans, or protectors. Compose a graphic narrative that portrays a problem that needs to be solved, which can be based on social injustice experienced or witnessed. Compose new text-bubbles, as does Stein in her art, to voice upstander concerns.

A Manifesto for Future Encounters

Artists and educators have an indispensable role to play in advocating for just and equitable futures for all. The following are *upstander* strategies for artists and teachers:

Be Bold! Bring to the forefront the political, effective, and ethical dimension of education into your (our) art and teaching practice.

Be Fierce! Use the saturation of images in everyday life and visual culture to fight complacency and disillusionment through creative art interventions. Harness ways to rethink oppressive, unthinkable conditions to create sites of action, empowerment, and agency. Linda Stein's work is a paradigmatic example.

Be Indignant! unflinching about the rights of people to demand an ethic based on social interdependence, social responsibility, and planetary interconnectivity with regard to education, dignity, peace, and happiness.

Be a Brave Upstander! about all human suffering, and audaciously provide the necessary tools to help others (e.g., our students); understand and confront how the extant political, economic, and social conditions enable and constrain structural violence at all levels of society.

Fierce feminist leaders stand up for justice. They believe they can be agents of change to transform structural barriers that deny equitable opportunities and circumstances for all to thrive and achieve in a world free from oppression. ■

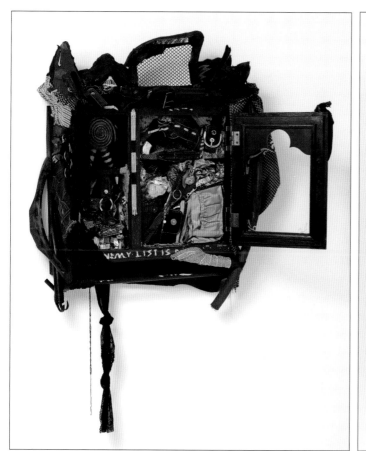
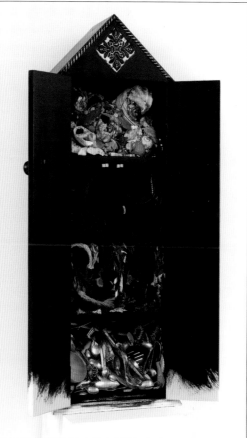

FIG. 33. Three works from the series *Cabinets, Cupboards, Cases and Closets*, 2015. Top left: *Brought/Left Behind 856*. Wood, metal, fabric, and mixed media; closed: 47 x 30 x 11 inches, mostly opened: 47 x 33 x 16 inches. Top right: *Four Stories 862*. Wood, fabric, metal, and mixed media; closed: 40½ x 13½ x 8 inches, mostly opened 40½ x 21 x 13 inches. Bottom: *Caged Compartment 855*. Wood, metal, fabric, and mixed media; closed: 9 x 9 x 3 inches, mostly opened: 9 x 17 x 7 inches.

Endnotes

Thoughts on Viewing *Holocaust Heroes: Fierce Females – Tapestries and Sculpture by Linda Stein* by Gloria Steinem, pp. 7–8

GLORIA STEINEM, born in 1934, is a writer and activist who first became recognized as a spokeswoman for the feminist movement in the late 1960s and early 70s. Her most recent book is *My Life on the Road* (2015), New York: Random House. Her other books include *Outrageous Acts and Everyday Rebellions* (1983), New York: Holt, Rinehart, and Winston; *Revolution from Within* (1992), Boston: Little, Brown; and *Moving beyond Words* (1993), New York: Simon & Schuster.

The Protector and Exemplar by Linda Stein, pp. 11–17

LINDA STEIN – artist-activist, lecturer, performer, video artist – is Founding President of the non-profit 501(c)(3) corporation, Have Art: Will Travel! Inc. (www.haveartwilltravel.org). Her Manhattan representative is Flomenhaft Gallery in Chelsea. Stein's archives are at Smith College. The Linda Stein Feminist Art Education Collection is to be housed at Penn State University Archives.

Notes

1. This story was inspired from reading Esther Dror and Ruth Linn, "The Shame is Always There," in *Sexual Violence Against Jewish Women during the Holocaust,* eds. Rochelle Saidel and Sonja Hedgepeth (Waltham, MA: Brandeis University Press, 2010) 275–291.

2. In his 2006 publication *Night*, Eli Weisel describes an experience as a prisoner in the concentration camp, when he was forced to sit stone (shell)-faced while beside him his father was being brutally tortured.

3. Amy Stone describes how she transcended her fear to face down a bully in the subway in "The Making of an Artist-Activist, Feminist Jew" *Na'amat Woman* (2015): 18-23.

4. I write about my brief time as a bully in Junior High School. Originally published in *On the Issues* Magazine it is available at: http://www.haveartwilltravel.org/sculptor-linda-stein-apologizes-to-the-girl-she-bullied-in-childhood/

5. Note that some scholars make a firm delineation between World War II and the Holocaust. I, on the other hand, have merged the two into what I refer to as *the time of the Holocaust.*

6. Of the many books I read, the seven that impacted me most make up my list of suggested reading.

7. See: Vollman Bible, Ann, "Ruptures of vulnerability: Linda Stein's Knight Series," *Journal of Lesbian Studies* 14 (2010): 154-173.

8. See additional writing on my blending of cultural gender attributions in: Penn-Goetsch, Christina. "Gladiators, Amazons, and Superheroes: Gender and the Recent work of Linda Stein," in *The Fluidity of Gender: Sculpture by Linda Stein* (exhibition catalog, 2010); Hobbs Thompson, Margo. *Body-Swapping, Empowerment and Empathy in Body-Swapping Armor: New Works by Linda Stein,* (exhibition catalog, 2009); Beckenstein, Joyce. "Gender Bending with Linda Stein," *Surface Design* (2013): 48-51.

9. I further explore my relationship to Judaism in Hinton, Laura. *Jayne Cortez, Adrienne Rich, and the Feminist Superhero: Voice, Vision, Politics, and Performance in U.S. Contemporary Women's Poetics* (Lanham, MD: Lexington Books, 2016).

10. See www.lindastein.com under "series" for images from each of these four periods of my work.

11. Additional writing on my experience during 9/11 can be found in the 2006 exhibition catalog, *The Power to Protect: Sculpture of Linda Stein.* See: Marter, Joan. "Regarding Stein's Knights and Glyphs," (pp. 5-14) and Hardacre, Helen. "Power and Protection: Japanese/American Crossroads and the Impact of 9/11 on the Sculpture of Linda Stein" (pp. 15-42).

12. My dreams came to me in a literal as well as visual form, complete with sentence structure and punctuation marks. The titles were spaced numbers representing the dates my dreams occurred:

 3 9 7 8
 I'm walking down the street and a group of boys try to rape me. I manage to get a pair of scissors, but I'm more frightened by having the scissors, than not.

 3 1 2 7 8
 When I'm being chased by military men, I'm Dustin Hoffman - small, frail, on my belly, crawl-running with my horse. If I could attach the rope nearby, the horse might pull me to safety.

1 0 2 9 9 0

There is a noise. I go to the door; it is slightly ajar. I have to close it, but as I push against it, I have no strength. Finally I get it to shut, but the huge man is coming in anyway. I'm able to hide under the stairway. Does he see me? Will he hurt me? What happened? It is not that (in the door) there is so much resistance to me: there is hardly any. But, even so, I do not have the strength or power to lock the door. And does a locked door make any difference?

1 1 1 7 2

The Nazis were rounding up the Jews again. They got me and took me to a room and told me I was going to be, along with the others, electrocuted. "You can electrocute me," I said, "but I want you to know that I have, as I had in the last holocaust, electrical insurance!"

13. See: Bader, Eleanor. "Sculpting strength: Artist Linda Stein casts heroes." *The Progressive* (2011): 37–39. See also: "Which of these Heroic Holocaust Women have you Heard of? *Lilith* (2016) available at: http://lilith.org/blog/2016/02/which-of-these-heroic-holocaust-women-have-you-heard-of/

14. See: Stein, Linda. "Wonder Woman: A Comic Book Character Shows the Way," *On the Issues Magazine* (2010). Available at: http://www.ontheissuesmagazine.com/2010winter/2010winter_Stein.php

15. See Stein, Linda. "Icons, Superheroes and Fantasies a Feminist Can Love?" *On the Issues Magazine* (Winter 2011). Available at: *http://www.ontheissuesmagazine.com/2011winter/2011_winter_Stein.php*

16. For further reading on my desire to address the environment see: Filippone, Christine. "Ecological Systems Thinking in the Work of Linda Stein." *Woman's Art Journal, 34* (2013): 13–20. Also, see Stein's series: *I Am the Environment: My Gender, My Nature* at http://www.lindastein.com/series/i-am-the-environment/

17. See: Matlock, Jann. "Vestiges of new battles: Linda Stein sculpture after 9/11." *Feminist Studies 33* (2007): 569–590.

18. See: www.haveartwilltravel.org for more information about Have Art Will Travel! Inc.

19. See: http://h2f2encounters.cyberhouse.emitto.net/ for more information about curricular encounters with *Holocaust Heroes: Fierce Females.*

20. *Holocaust Heroes: Fierce Females,* DVD, directed by Lily Henderson and produced by Sarah Connors and Linda Stein (USA: Have Art Will Travel Inc., 2015). This 7-minute film starring Abigail Disney, Eva Fogelman, Raymond Learsy, Menachem Rosensaft, Elizabeth Sackler, Linda Stein and Gloria Steinem, is about ten female heroes of the time of the Holocaust, and the ten large sculptural tapestries that were made about them. The 4 B's: BULLY, BULLIED, BYSTANDER and BRAVE

UPSTANDER are also described by artist Linda Stein. On YouTube, https://www.youtube.com/watch?v=gzlib-NqYvs&hd=1.

Suggested Reading:

Fogelman, Eva. *Conscience & Courage: Rescuers of Jews During the Holocaust.* New York: Anchor Books, 1994.

Frankl, Victor. *Man's Search for Meaning.* Boston, MA: Beacon Press, 1959.

Hedgepeth, Sonja and Saidel, Rochelle. *Sexual Violence Against Jewish Women During the Holocaust.* Waltham, MA: Brandeis University Press, 2010.

Herman, Judith Lewis. *Trauma and Recovery.* New York, NY: Basic Books, 1992.

Kershaw, Ian. *Hitler: A Biography.* New York NY: W. W. Norton & Company, 2008.

Shirer, William L. *The Rise and Fall of the Third Reich: a History of Nazi Germany.* New York, NY: Simon and Schuster, 1960.

Wiesel, Eli and Wiesel, Marion. *Night.* New York, NY: Hill and Wang, a division of Farrar, Straus and Giroux, 2006.

Forgotten Female Holocaust Heroes by Eva Fogelman, pp. 19–23

EVA FOGELMAN Ph.D. was born in a displaced persons camp in Kassel, Germany after WWII. She is a social psychologist, psychotherapist, author and filmmaker with a private practice in New York City. Her book, *Conscience and Courage: Rescuers of Jews During the Holocaust* (1994), New York: Anchor Books, was nominated for a Pulitzer Prize. Dr. Fogelman is co-editor of *Children During the Nazi Reign: Psychological Perspective on the Interview Process* (1994), Westport, CT: Praeger, and the writer and co-producer of the award winning documentary *Breaking the Silence: The Generation After the Holocaust* (1984) PBS.

Notes

1. Henry Rousso, *The Vichy Syndrome: History and Memory in France Since 1944.* (Cambridge: Harvard University Press, 1991), 58.

2. Kay Deaux, *The Behavior of Women and Men.* (Monterey: Brooks/Cole Publishing Company, 1976).

3. Sigmund Freud, "Some Psychical Consequences of the Anatomical Distinction Between the Sexes," *Standard Edition,* 19 (1925): 257.

4. Alice Eagley and Maureen Crowley, "Gender and Helping Behavior: A Meta-Analytic Review of the Social Psychological Literature," *Psychological Bulletin,* 100, no. 3 (1986): 283–308.

5. Ibid.

6. Carol Gilligan, *In a Different Voice: Psychological Theory and Women's Development.* (Cambridge, MA: Harvard University Press, 1982).

7. Carol Tavris, *The Measure of Women: Why Women Are Not the Better Sex, the Inferior Sex or the Opposite Sex.* (New York: Simon and Schuster, 1992), 289.

8. Staub, Ervin "Helping a Distressed Person: Social Personality and Stimulus Determinants." In *Advances in Experimental Social Psychology,* edited by L. Berkowitz, 293-342. New York: Academic Press, 1974.

9. For more information regarding Raoul Wallenberg see the United State Holocaust Memorial Museum Website: https://www.ushmm.org/wlc/en/article.php?ModuleId=10005211

10. Freud, 257.

11. Eva Fogelman, *Conscience and Courage: Rescuers of Jews During the Holocaust.* (New York: Anchor Books of Random House, 1994), 237.

12. Hannah Senesh, *Hannah Senesh: Her Life and Diary.* (New York: Schocken Books, 1972).

13. Abba Eban's Introduction in *Hanna Senesh: Her Life & Diary.* (New York: Schocken Books, 1972), ix.

14. Senesh, 63.

15. Yitzchak Mais, "Jewish Life in the Shadow of Destruction." In *Daring to Resist: Jewish Defiance in the Holocaust,* edited by Yitzchak Mais, 18-24. New York: Museum of Jewish Heritage, 2007.

16. *The Diary of Anne Frank* was originally published in June, 1947 in Holland, in 1950 in France and Germany, and in 1952 in the United States.

17. Anne Frank, *Diary of a Young Girl.* (New York: Pocket Books, Doubleday,1952), 131.

18. Nancy Wake, *The Autobiography of the Woman the Gestapo Called the White Mouse.* (Sydney, Australia: Sun Books, 1985), 4.

19. Fogelman, 197.

20. Albert Schweitzer, "Albert Schweitzer: Thoughts for Our Times" edited by Erica Anderson (Mount Vernon, NY: The Peter Pauper Press, 1975)

21. Senesh, 13.

Suggested Reading

Fogelman, Eva. *Conscience & Courage: Rescuers of Jews During the Holocaust.* New York: Anchor Books, 1994.

Frankl, Victor. *Man's Search for Meaning.* Boston, MA: Beacon Press, 1959.

Hedgepeth, Sonja and Saidel, Rochelle. *Sexual Violence Against Jewish Women During the Holocaust.* Waltham, MA: Brandeis University Press, 2010.

Herman, Judith Lewis. *Trauma and Recovery.* New York, NY: Basic Books, 1992.

Kershaw, Ian. *Hitler: A Biography.* New York NY: W. W. Norton & Company, 2008.

Shirer, William L. *The Rise and Fall of the Third Reich: a History of Nazi Germany.* New York, NY: Simon and Schuster, 1960.

Wiesel, Eli and Wiesel, Marion. *Night.* New York, NY: Hill and Wang, a division of Farrar, Straus and Giroux, 2006.

Anne Frank: A Girl and a Symbol
by David Barnouw, pp. 27–29

DAVID BARNOUW, born in 1949 in Retranchement, a small Dutch village near the Belgian border, now lives in Amsterdam. He has been a researcher and director of communication at NIOD, Dutch Institute for War, Holocaust and Genocide Studies. His third book on Anne Frank, *The Anne Frank Phenomenon (2012),* was published in the Netherlands and soon will be published in the USA. He frequently lectures on Anne Frank in the United States.

Notes

1. Anne Frank, *Anne Frank: The Diary of a Young Girl,* Thursday July 9, 1942

2. Anne Frank, *Anne Frank: The Diary of a Young Girl,* Sunday January 2, 1944

3. Miep Gies with Leslie Gold, *Anne Frank Remembered. The Story of the Woman Who Helped to Hide the Frank Family.* (New York: Simon & Schuster, 1987).

Suggested Reading

Barnouw, David. *Het fenomeen Anne Frank.* Amsterdam: Bert Bakker, 2012.

Frank, Anne, H. J. J. Hardy, David Barnouw, and Gerrold van der Stroom. *The Diary of Anne Frank: The Critical Edition.* New York: Doubleday, 2003.

Bloom, Harold, *Scholarly Look at the Diary of Anne Frank.* ed. Philadelphia, PA: Chelsea House, 1999.

Enzer, Herman A. and Solotaroff-Enzer, Sandra. eds. *Anne Frank: Reflections on Her Life and Legacy,* Urbana and Chicago: University of Illinois Press 2000.

Ruth Gruber: My Hero
by Patti Askwith Kenner, pp. 31–33

PATTI KENNER lives in New York City, and runs Campus Coaches, a family business started by her father over 70 years ago. She is active in many social and political causes and serves on the boards of the Museum of Jewish Heritage - A Living Memorial to the Holocaust, Educational Alliance, American Heart Association, Carnegie Mellon University, Guild Hall, and the University Musical Society at University of Michigan. She co-chaired the *Defiant Requiem* concerts at Lincoln Center in 2013 and 2015 and was instrumental in helping raise over $4.0 million for Holocaust survivors in collaboration with UJA-Federation of NY.

Notes

1. FDR issued the invitation by executive order, circumventing Congress's refusal to lift - or even meet - the quota on Jewish immigrants.

2. For information on this traveling exhibition, see: http://www.icp.org/exhibitions/ruth-gruber-photojournalist.

3. Ruth inspired me. In spite of my just being a business woman running a bus company with my then 97 year old father (who founded and ran the company until the age of 104 when he passed away), and knowing nothing about making a documentary film, I still believed that I could do anything.

4. Doris Schechter was one of the refugees whom Ruth escorted from Italy to America on the *Henry Gibbons* in 1944, when Doris was a little girl.

5. Henry Jarecki later joined as our fourth executive producer.

6. For more information about the film and how to access it, see: http://www.jewishfilm.org/Catalogue/films/aheadoftime.htm

Suggested Reading

Gruber, Ruth and Mazal Holocaust Collection. *Haven: The Unknown Story of 1,000 World War II Refugees.* New York: Coward-McCann, 1983.

Gruber, Ruth. *Witness: One of the Great Correspondents of the Twentieth Century Tells her Story.* New York: Schocken Books, 2007.

Gruber, Ruth. *Inside of Time : My Journey from Alaska to Israel.* New York : Carroll & Graf, 2003.

Richman, Bob, director. *Ahead of time: The Extraordinary Journey of Ruth Gruber.* DVD. United States: A Reel Inheritance, 2009.

Vitka Kempner: Courageous and Modest
by Michael Kovner and Eva Fogelman, pp. 35–37

MICHAEL KOVNER, the son of Vitka Kempner and Abba Kovner, grew up on Kibbutz Ein Ha-Horesh. He now lives in Jerusalem. He is the author of the graphic novel *Ezekial's World* (2013) Cohel Publishing House.

Notes

1. Waletzky, Josh, Aviva Kempner, and Roberta Wallach. *Partisans of Vilna.* New York, NY: Docurama, 2005. About Vitka Kempner, Aviva Kempner (no relation) states, "She was the most courageous and modest woman I ever met."

2. See: Rich Cohen, *The Avengers: A Jewish War Story.* (New York: Random House, 2000)

3. See also: Barzel, Neima. "Vitka Kempner-Kovner." Jewish Women: A Comprehensive Historical Encyclopedia. 1 March 2009. Jewish Women's Archive. http://jwa.org/encyclopedia/article/kempner-kovner-vitka. And: Jewish Women's Archive. "Vitka Kempner, Abba Kovner, Rozka Korczak-Marla and Fellow Partisans, July 1944." http://jwa.org/media/kempner-vitka-small-still-image.

4. Michael also published his graphic novel, "Ezekiel," based on his father Abba's last years. The novel, which serves as a basis for a play of the same name, was produced in New York and at Jerusalem's Khan Theatre. See: http://www.michaelkovner.com.

5. "B'richa" is Hebrew for "escape" and was a post-war underground operation smuggling Jews out of Soviet-occupied countries with the goal of reaching Palestine.

Suggested Reading

Cohen, Rich. *The Avengers: A Jewish War Story.* New York: Alfred A. Knopf, 2000.

Porat, Dina. *The Fall of the Sparrow: The Life and Times of Abba Kovner.* Stanford, California: Stanford University Press, 2010.

Kovner, Michael. *Ezekiel's World.* 2012. Graphic Novel Published by the artist/author.

Noor Inayat Khan: Indian Princess and Secret Agent
by Shrabani Basu, pp. 39–41

SHRABANI BASU is the author of *Spy Princess, The Life of Noor Inayat Khan.* She is the founder and chair of the Noor Inayat Khan Memorial Trust and led a high profile campaign for a Memorial for Noor in London. Her other books include *Victoria & Abdul, The True Story of the Queen's Closest Confidant* and *Curry, The Story of Britain's Favourite Dish.* Her latest book is *For King and Another Country, Indian Soldiers on the Western Front 1914-18.*

Suggested Reading

Basu, Shrabani. *Spy princess: The Life of Noor Inayat Khan.* Stroud, UK: Sutton Publishing, 2006.

Binney, Marcus. *The Women who Lived for Danger.* London: Coronet, 2002.

Buckmaster, Maurice. *They Fought Alone.* London: Popular Book Club, 1958.

Escott, Beryl E. *WAAF: A history of the Women's Auxiliary Air Force in the Second World War.* Buckinghamshire, UK: Shire Books, 2003.

Foot, Michael. *SOE in France (revised edition)* Abingdon, Oxford, UK: Frank Cass, 2004.

Helm, Sarah. *A Life in Secrets: The Story of Vera Atkins and the Lost Agents of the SOE.* New York: Anchor Books, 2005.

Kramer, Rita. *Flames in the Field.* London: Penguin Books, 1996.

Marks, Leo. *Between Silk and Cyanide: A Codemaker's War 1941–45.* New York: Touchstone, 2000.

Overton, Jean Fuller. *Madeleine: The Story of Noor Inayat Khan.* London: Victor Gollancz, 1952.

Verity, Hugh. *We Landed by Moonlight (revised 2nd edition).* Manchester: Crecy Publishing, 2000.

Zivia Lubetkin: Tough and Compassionate
by Dalia Ofer, pp. 43–45

DALIA OFER is professor emerita of history at the Hebrew University of Jerusalem. Her research has focused on the Holocaust period and the social history of the Jews in east European ghettos. Among her publications: *Escaping the Holocaust: Illegal Immigration to the Land of Israel, 1939-1944* in Hebrew and English versions (Yad Ben Zvi, Jerusalem, 1990; Oxford University Press, New York, 1998), which received the Ben Zvi award and a National Jewish Book Award; and *Israel in the Eyes of Survivors of the Holocaust* (Yad Vashem, Jerusalem, 2014. In Hebrew). Her most recent publication is *The Clandestine History of the Kovno Jewsih Ghetto Police* (Yad Vashem, Jerusalem, 2016. In Hebrew).

Notes
1. Fatal-Kna'ani, Tikva. "Zivia Lubetkin." Jewish Women: A Comprehensive Historical Encyclopedia. 1 March 2009. Jewish Women's Archive. Available at: http://jwa.org/encyclopedia/article/lubetkin-zivia.
2. Gutman, Israel, Zivia Lubetkin, in the Encyclopedia of the Holocaust, New York: Macmillan (1990), vol.3, pp. 914-915.
3. Bella Gutterman, *Fighting for her people: Zivia Lubetkin, 1914-1978,* (Jerusalem: Yad Vashem Publications, 1978), 130.
4. *Israeli Attorney General against Adolf Eichmann, Testimonies, Testimony of Zivia Lubetkin,* 1963, vol. 1, p.253 (Hebrew), Jerusalem, Office of the Prime Minister, Available at: http://www.nizkor.org/hweb/people/e/eichmann-adolf/transcripts/Sessions/Session-025-01.html

Suggested Reading
Barzel, Neima. *Sacrificed Unredeemed* (Hebrew), Jerusalem: Hasifriyyah Haziyonit, 1998.
Dror, Zvika. *Testimonies of survival: Ninety-six personal interviews from Kibbutz Lochamei ha-Getta'ot* (Hebrew), Tel Aviv: Sifriyyat Hapoalim, 1984.
Fatal-Kna'ani, Tivka. *Zivia Lubetkin, Jewish Women: A Comprehensive Historical Encyclopedia.* 1 March 2009. Jewish Women's Archive. Available at: http://jwa.org/encyclopedia/article/lubetkin-zivia.
Gutterman, Bella. *Fighting for her People: Zivia Lubetkin, 1914-1978,* Jerusalem: Yad Vashem Publications, 1978.
Kibbutz Lohamei Hagettaot. Zivia: 9.11.1914-11.7.1978 *Special edition of Dapim, the Kibbutz Lohamei Hagettaot Bulletin* (Hebrew) Lohamei Hagettaot, 1978.
Lubetkin, Zivia. "The Last Ones on the Wall" (Address to the 15th conference of Hakibbutz Hameuhad, Yagur, 8 June 1946 [Hebrew]), Hakibbutz Hamechad, Ein Harod, 1947.
Lubetkin, Zivia. *In the Days of Destruction and Revolt.* Ein Harod: Hakibbutz Hamechad, 1981.

Gertrud Luckner: Devoted to Christian–Jewish Reconciliation
by Carol Rittner, pp. 47–49

Carol Rittner, RSM, D.Ed, a member of the Roman Catholic Religious Sisters of Mercy, is Distinguished Professor of Holocaust and Genocide Studies Emerita and the Dr. Marsha Raticoff Grossman Professor of Holocaust Studies Emerita at Stockton University in New Jersey. She is the author or editor of 20 books and numerous essays in scholarly and educational journals about the Holocaust and other genocides of the 20th and 21st centuries.

Notes
1. "Gertrud Luckner" in Gay Block and Malka Drucker, *Rescuers: Portraits of Moral Courage in the Holocaust* (New York: Holmes & Meier Publishers, Inc.,1992) 146.
2. Ibid.
3. Elizabeth Petuchowski, "Gertrud Luckner: Resistance and Assistance. A German Woman Who Defied Nazis and Aided Jews," in *Ministers of Compassion During the Nazi Period*, The Institute of Jewish-Christian Studies, South Orange, N.J., 1999) 7.
4. Ibid., 8
5. Ibid., 9
6. Ibid., 8
7. Ibid., 9
8. Michael Phayer, *The Catholic Church and the Holocaust, 1930-1965,* (Bloomington: Indiana University Press, 2000) 185.
9. See Yad Vashem, The Righteous Among the Nations. Retrieved from: http://www.yadvashem.org/yv/en/righteous/stories/luckner.asp

Suggested Reading
Block, Gay. and Drucker, Malka. *Rescuers: Portraits of Moral Courage in the Holocaust.* New York: Holmes & Meier Publishers, Inc., 1992.
Petuchowski, Elizabeth. "Gertrud Luckner: Resistance and Assistance. A German Woman who Defied Nazis and Aided Jews." In *Ministers of Compassion During the Nazi Period*, edited by Lawrence Frizzell. South Orange, NJ: The Institute of Jewish-Christian Studies,1999. 5-21.
Phayer, Michael. *The Catholic Church and the Holocaust. 1930-1965.* Bloomington: Indiana University Press, 2000.
Phayer, Michael and Fleischner, Eva. *Cries in the Night: Women Who Challenged the Holocaust.* Kansas City: Sheed & Ward, 1997.

Nadezha Popova: Hero of the Soviet Union
by Molly Merryman, pp. 51–53

MOLLY MERRYMAN, Ph.D., is director of the Center for the Study of Gender and Sexuality at Kent State University. She is associate professor of sociology at Kent State, where she coordinates the LGBT studies program and teaches courses in victimology and inequalities. She is the author of *Clipped Wings: The Rise and Fall of the Women Airforce Service Pilots of World War II* (New York University Press, 1998). She is currently editing a documentary on the San Francisco Bay Area Chapter Sex Workers Outreach Project and conducting fieldwork on an oral history and documentary on LGBTQ lives in Ohio. Email mmerryma@kent.edu/

Notes

1. Anne Noggle, *A Dance with Death: Soviet Airwomen in World War II.* (USA: Texas A&M University Press, 1994), 80.
2. David Childs, "Nadezhda Popova: Soviet Pilot Known as 'The Night Witch'. *The Independent,* July 16, 2013. http://www.independent.co.uk/news/obituaries/nadezhda-popova-soviet-pilot-known-as-the-night-witch-8711677.html
3. Noggle, ibid.
4. United States Holocaust Memorial Museum. *Nazi Persecution of Soviet Prisoners of War.* Holocaust Encyclopedia. https://www.ushmm.org/wlc/en/article.php?ModuleId=10007178
5. United States Holocaust Memorial Museum. *The Treatment of Soviet POWs: Starvation, Disease and Shootings, June 1941–January 1942.* Holocaust Encyclopedia. Available at: http://www.ushmm.org/wlc/en/article.php?ModuleId=10007183
6. The National World War II Museum. *By the numbers: The Holocaust.* http://www.nationalww2museum.org/learn/education/for-students/ww2-history/ww2-by-the-numbers/holocaust.html
7. Alexandra Valiete, "The Historic Role that Soviet Women Played in Defeating the Nazis in World War II," *Global Research,* March 8, 2014. https://libya360.wordpress.com/2014/03/08/the-historic-role-that-soviet-women-played-in-defeating-the-nazis-in-world-war-ii/
8. Douglas Martin, "Nadezhda Popova: WWII 'Night Witch' dies at 91." *The New York Times,* July 14,2013. http://www.nytimes.com/2013/07/15/world/europe/nadezhda-popova-ww-ii-night-witch-dies-at-91.html?_r=0
9. Lyuba Pronina, "The witch who flew over Nazis by night." *The Moscow Times,* May 8, 2001. http://www.themoscowtimes.com/sitemap/free/2001/5/article/the-witch-who-flew-over-nazis-by-night/253704.html
10. Childs, ibid.
11. Megan Garber, "Night Witches: The Female Fighter Pilots of World War II," *The Atlantic,* July 15, 2013. http://www.theatlantic.com/technology/archive/2013/07/night-witches-the-female-fighter-pilots-of-world-war-ii/277779/
12. Captain Nancy Aldrich, "The Witch Is Dead," 20th *Century Aviation Magazine,* http://20thcenturyaviationmagazine.com/o-capt-nancy-aldrich/the-witch-is-dead/

Suggested Reading

Bresky, Gunilla. producer and director. *Night Witches.* Documentary. Sweden: SVT, 2008. http://svtsales.com/programme-sales/night-witches/.
Elshtain, Jean Bethke. *Women and War.* New York: Basic Books, 1987.
Noggle, Anne. *A Dance with Death: Soviet Airwomen in World War II.* USA: Texas A&M University Press, 1994.
Pennington, Reina. *Wings, Women and War: Soviet Airwomen in World War II Combat.* Lawrence, KS: University Press of Kansas, 2002.
Strebe, Amy. *Flying for Her Country: The American and Soviet Women Military Pilots of World War II.* Westport, CT: Praeger Press, 2007.
Timofeyeva-Yegorova, Anna Aleksandrovna. *Red Sky, Black Death: A Soviet Woman Pilot's Memoir of the Eastern Front.* Bloomington, IN: Slavica Publishers, 2009.

Hadassah Bimko Rosensaft: Saving Others
by Menachem Z. Rosensaft, pp. 55–57

MENACHEM Z. ROSENSAFT, who was born in the Displaced Persons camp of Bergen-Belsen on May 1, 1948, is general counsel of the World Jewish Congress and lectures on the law of genocide and war crimes trials at the law schools of Columbia and Cornell Universities. He is founding chairman of the International Network of Children of Jewish Holocaust Survivors, a past president of Park Avenue Synagogue in Manhattan, and editor of *God, Faith & Identity from the Ashes: Reflections of Children and Grandchildren of Holocaust Survivors*, Jewish Lights Publishing, Woodstock, Vt. (2015). He lives in New York City.

Notes

1. Testimony of Ada Bimko, September 21, 1945, Transcript of the Official Shorthand Notes of "The Trial of Josef Kramer and Forty Four Others," Retrieved from http://www.bergenbelsen.co.uk/pages/TrialTranscript/Trial_Contents.html.
2. Alexander Easterman, "The Trial of German Hangmen," Congress Weekly, October 6, 1945, p. 10.

3. S.J. Goldsmith, Jews in Transition, (Herzl Press, New York, 1969), p. 107

4. Hadassah Rosensaft, Yesterday: My Story (Yad Vashem, New York, Jerusalem, 2005), p. 30

5. Ibid

6. Ruth Fenton, "A Miracle in Auschwitz-Birkenau," in Holocaust Commemorative in Memory of the Six Million, G. Goetz, ed. (The "1939" Club, Inc., Los Angeles, 1978) p. 50

7. See generally, Plotkin, D, "The Kinderheim of Bergen-Belsen," in Jewish Medical Resistance in the Holocaust, M. Grodin, ed. (New York, Oxford: Berghahn Books. 2014), pp. 206-218

8. Ritvo, Roger A., and Plotkin, Diane M., Sisters in Sorrow: Voices of Care in the Holocaust (Texas A&M University Press, College Station, 1998), p. 181

9. Id., p. 182

10. Hadassah Rosensaft, Yesterday: My Story, supra note 4, p. 45

11. Ibid

12. Hetty Verolme, The Children's House of Belsen (Australia: Freemantle Arts Centre Press, 2000), p. 161

13. Beighton, K., "There was good among the evil," BBC News, January 26, 2006. Retrieved from http://news.bbc.co.uk/2/hi/uk_news/4638794.stm

14. The Liberation of the Nazi Concentration Camps 1945: Eyewitness Accounts of the Liberators, B. Chamberlin and M. Feldman, eds. (United States Holocaust Memorial Council, Washington, D.C., 1987), pp. 65-66

15. Ben Shephard, After Daybreak: The Liberation of Bergen-Belsen, 1945 (Schocken Books, New York, 2005), p. 49

16. S.J. Goldsmith, Jews in Transition, supra note 3, p. 107

Suggested Reading

Gill, Anton, The Journey Back From Hell: Conversations with Concentration Camp Survivors, Grafton Books, London (1988)

Goldsmith, S.J., "Hadassah Rosensaft," in Jews in Transition, Herzl Press, New York (1969)

Pace, Eric, "Hadassah Rosensaft, 85, Dies; Saved Auschwitz Inmates," The New York Times, October 8, 1997, B7, col. 1

Plotkin, Diane, "The Kinderheim of Bergen-Belsen," in Jewish Medical Resistance in the Holocaust, Michael A. Grodin, editor, Berghahn Books, New York, Oxford (2014)

Ritvo, Roger A. and Diane M. Plotkin, Sisters in Sorrow: Voices of Care in the Holocaust, Texas A&M University Press, College Station (1998)

Rosensaft, Hadassah, Yesterday: My Story, Yad Vashem, New York, Jerusalem (2005)

Rosensaft, Hadassah "Holocaust Survivor Hadassah Rosensaft Describes the Day She Was Liberated From a Nazi Extermination Camp," In Our Own Words: Extraordinary Speeches of the American Century, Sen. Robert Torricelli and Andrew Carroll, editors, Kodansha International, New York, Tokyo and London (1999)

Shephard, Ben, After Daybreak: The Liberation of Bergen-Belsen, 1945, Schocken Books, New York (2005)

Hannah Senesh: Stoic and Rebellious Poet
by Marge Piercy, pp. 59–61

Poet, novelist, essayist **MARGE PIERCY**'s 19th poetry book, *Made in Detroit*, was published in 2015 by Alfred A. Knopf. Harper Perennial has Piercy's 17th novel, *Sex Wars*, and her memoir, *Sleeping with Cats*. A powerful feminist and Jewish voice, Piercy's poetry volumes include *The Moon is Always Female* and *The Art of Blessing the Day*. Her novels include *Woman on the Edge of Time* and the bestseller set in World War II, *Gone to Soldiers*. The paperback edition of Piercy's first short story collection, *The Cost of Lunch, Etc.*, has a 2015 publication date with new stories added.

Suggested Reading

Atkinson, Linda. *In Kindling Flame: The Story of Hannah Senesh, 1921-1944*. New York: Lothrop, Lee & Shepard Books, 1985.

Grossman, Roberta, director. *Blessed is the Match*. DVD. United States: Katahdin Productions, 2008.

Masters, Anthony. *The Summer That Bled; The Biography of Hannah Senesh*. New York: St. Martin's Press, 1972.

Senesh, Hannah. *Hannah Senesh: Her life and Diary, the first complete edition*. Woodstock, VT: Jewish Lights Publishing, 2004.

Nancy Wake: The Feminine/Masculine "White Mouse"
by Kathryn J. Atwood, pp. 63–65

KATHRYN J. ATWOOD is the author of three young adult histories of women and war: *Women Heroes of World War I*, *Women Heroes of World War II* and *Women Heroes of World War II: The Pacific Theater* (October, 2016). She is the editor of *Code Name Pauline: Memoirs of a World War II Special Agent* (the memoir of SOE agent Pearl Witherington). Her website is www.kathrynatwood.com/

Notes

1. Peter FitzSimons, *Nancy Wake: A Biography of Our Greatest War Heroine*. (Australia: HarperCollins, 2001), 122-123.

2. Nancy Wake, *The Autobiography of the Woman the Gestapo Called the White Mouse*. (Sydney,

Australia: Sun Books, 1985), 4.
3. Ibid., 48.
4. FitzSimons, *Nancy Wake: A Biography of Our Greatest War Heroine*, 266.
5. Wake, *The Autobiography of the Woman the Gestapo Called the White Mouse*, 142.
6. Ibid., 143.
7. Ibid., 142.
8. Ibid., 137.
9. Russell Braddon, *Nancy Wake: SOE's Greatest Heroine*, (London: Cassell & Co. Ltd, 1956; The History Press, 2009).

Suggested Reading

Atwood, Kathryn J. *Women Heroes of World War II: 26 Stories of Espionage, Sabotage, Resistance, and Rescue*. Chicago, Ill.: Chicago Review Press, 2011.

Binney, Marcus. *The Women Who Lived for Danger: The Agents of the Special Operations Executive*. Great Britain: Hodder and Stoughton, 2002.

Braddon, Russell. *Nancy Wake: SOE's Greatest Heroine*. London, Quality Book Club, Cassell & Co. Ltd, 1956: The History Press, 2009.

Escott, Beryl E. *The Heroines of SOE F Section: Britain's Secret Women in France*. Gloucestershire: The History Press, 2010.

FitzSimons, Peter. *Nancy Wake: A Biography of Our Greatest War Heroine*. Australia: HarperCollins, 2001.

Wake, Nancy. *The Autobiography of the Woman the Gestapo Called the White Mouse*. Sydney, Australia: Sun Books, 1985.

Linda Stein's *Holocaust Heroes: Fierce Females* and Related Works by Gail Levin, pp. 67–70

GAIL LEVIN is Distinguished Professor at Baruch College and the Graduate Center of the City University of New York; among her many books and articles are biographies of Edward Hopper, Judy Chicago, and Lee Krasner.

Notes

1. Gail Levin, *Lee Krasner: A Biography*. (New York: William Morrow, 2011), 411.
2. In 2012, Lady Gaga, born Stefani Joanne Angelina Germanotta in 1986, established the Born This Way Foundation (BTWF), a non-profit organization that focuses on youth empowerment.
3. Tikun Olam is a Hebrew phrase for humanities' responsibility to repair or heal the world.
4. Gail Levin, *Becoming Judy Chicago: A Biography of the Artist*. (New York: Harmony Books, 2007), 357–367.
5. Linda Stein, "Guestwords: Lichtenstein Across the Net," The East Hampton Star, July 10, 2013. http://www.lindastein.com/about/bio/lichtenstein-across-net/.

6. Helen Hardacre is Reischauer Institute Professor of Japanese Religions and Society at Harvard University.
7. Gloria Steinem quoted in Jill Lepore, *The Secret History of Wonder Woman* (New York: Alfred A. Knopf, 2014), 285.
8. Stieg Larsson, *The Girl with the Dragon Tattoo* (New York: Alfred A. Knopf, 2008) was made into a film in 2009.
9. See Helen Hardacre, "Maitreya in Modern Japan," In *Maitreya, the Future Buddha*, eds. Alan Sponberg and Helen Hardacre (Cambridge: Cambridge University Press, 1988, reissued 2011). This book elsewhere references Kannon.
10. What Stein read was Esther Dror and Ruth Linn, "The Shame is Always There" in *Sexual Violence Against Jewish Women during the Holocaust*, eds. Rochelle Saidel and Sonja Hedgepeth (Waltham, MA: Brandeis University Press, 2010), 275–291.

Curricular Encounters with Linda Stein's Holocaust Heroes: Fierce Females by Karen Keifer-Boyd, Cheri Ehrlich, Ann Holt, Wanda B. Knight, Yen-Ju Lin, Adetty Pérez de Miles, and Leslie Sotomayor, pp. 71–74

KAREN KEIFER-BOYD, Ph.D., is professor of art education and women's, gender, and sexuality studies at The Pennsylvania State University, and 2012 Fulbright Distinguished Chair in Gender Studies at Alpen-Adria-Universität Klagenfurt, Austria. She co-authored *Including Difference: A Communitarian Approach to Art Education in the Least Restrictive Environment* (NAEA, 2013); *InCITE, InSIGHT, InSITE* (NAEA, 2008); *Engaging Visual Culture* (Davis, 2007); co-edited *Real-World Readings in Art Education: Things Your Professors Never Told You* (Falmer, 2000), and is co-founder and co-editor of *Visual Culture & Gender*.

CHERI E. EHRLICH, Ed.D., is an art and museum educator at the Museum of Arts and Design in New York City. Ehrlich also teaches as an assistant adjunct at Brooklyn College of the City University of New York. Her research on adolescents' responses to feminist artworks in the Elizabeth A. Sackler Center for Feminist Art at Brooklyn Museum is published in the journal, Visual Arts Research, and is discussed in a chapter of the book, Multiculturalism in Art Museums Today (Rowman & Littlefield, 2014).

ANN HOLT, Ph.D., is a visiting professor of art and design education at Pratt Institute and Executive Director of the non-profit, Have Art: Will Travel! Inc. Her publications concern marginalized histories of art education and feminist archives.

WANDA B. KNIGHT, Ph.D., is associate professor of art education and women's, gender, and sexuality studies at The Pennsylvania State University. A previous editor of the *Journal of Social Theory in Art Education,* she has published and presented her research concerning culturally competent teaching and entanglements of difference (race, class, gender) in leading scholarly venues.

YEN-JU LIN, Ph.D., is a museum art educator, instructional technologist, researcher, graphic designer, and a feminist. Her work at the National Palace Museum involved curating new educational media for translating ancient museum artifacts into meaningful narratives for museum visitors.

ADETTY PÉREZ de MILES, Ph.D., is an Assistant Professor at the College of Visual Arts & Design at the University of North Texas. She has authored publications on visual culture, dialogic pedagogy, feminist epistemology, Latin American art, and emergent art practices informed by robotics and new media.

LESLIE SOTOMAYOR is an artist, feminist curator, and doctoral candidate at The Pennsylvania State University. She curated *Borrandofronteras/ Erasingborders* with Cuban and Cuban-American artists in 2015.

Notes

1. The exhibition consists of: 10 tapestries (each five-foot square leather, metal, canvas, paint, fabric and mixed media); 20 box sculptures of spoons, shells, mixed media, and text fragments, and one *Protector* sculpture (made of leather, metal, and Stein collected objects) with a *Wonder Woman* shadow. Accompanying the exhibition is a seven-minute video about the artist's inspiration and artmaking process, as well as curriculum available online at http://h2f2encounters.cyberhouse. emitto.net/.

2. Paul Vitello, "Nancy Wake, proud spy and Nazi foe, dies at 98," *The New York Times,* August 13, 2011, http://www.nytimes.com/2011/08/14/world/ europe/14wake.html?_r=0.

3. Amy Stone, "Linda Stein: The making of an artist-activist, feminist Jew," *NA'AMAT* 30 (2015): 18-23.

4. See: *Have Art: Will Travel! For Gender Justice.* www.haveartwilltravel.org.

5. See: National Art Education Association Research Commission (2014): p. 3. Available at: https:// www.arteducators.org/research/commission/ Research_Agenda_Digital.pdf.

6. See: http://h2f2encounters.cyberhouse.emitto. net/category/encounters/.

7. Michael Vavrus, *Diversity & Education: A Critical Multicultural Approach.* (New York, NY: Teachers College Press, 2015).

8. *Holocaust Heroes: Fierce Females*, DVD, directed by Lily Henderson (New York, NY: Have Art Will Travel! Inc., 2015). Produced by Sarah Connors and Linda Stein and available online at: http://www.haveartwilltravel.org/events/ holocaust-heroes/

9. To join the discussion, visit http:// h2f2encounters.cyberhouse.emitto.net/ interactive-arts/.

10. Frank Hernandez, "Critical Components of Preparing Professionals for Social Justice Across Three Disciplines: Implications for School Leadership Programs," *Journal of Research on Leadership Education,* 5 (2010): 43-47.

11. Ka-Ping Yee, (2005). Regender: A Different Kind of Translator, http://regender.com/

12. See: http://h2f2encounters.cyberhouse.emitto. net/justice/

13. Amy Goodman, "Nativist Hysteria Against Syrian Refugees Echoes U.S. Rejection of Jewish Refugees in the 1930s," PBS *Democracy Now: Independent Global News,* November 24, 2015, available at: http://www.democracynow.org/2015/11/24/ nativist_hysteria_against_syrian_refugees_echoes

14. *Voyage of the Damned,* Motion Picture, directed by Stuart Rosenberg, (United Kingdom: AVCO Embassy Pictures, 1976)

Suggested Reading

Chicago, Judy. *Institutional Time: A Critique of Studio Art Education.* New York, NY: Monacelli Press, 2014.

Connell, Raewyn, and Pearse, Rebecca. *Gender in World Perspective* 3rd ed. Malden, MA: Polity, 2015.

Chambers, Iain, De Angelis, Alessandra, Ianniciello,Celeste, Orabona, Mariangela and Quadraro, Michaela, eds. *The Postcolonial Museum: The Arts of Memory and the Pressures of History.* Farnham, United Kingdom: Ashgate Publishing, 2014.

Mann, Susan Archer. *Doing Feminist Theory: From Modernity to Postmodernity.* Oxford; New York, NY: Oxford University Press, 2012.

Martusewicz, Rebecca, Edmundson, Jeff, and Lupinacci, John. *EcoJustice Education: Toward Diverse, Democratic, and Sustainable Communities.* New York, NY: Routledge, 2015.

Vavrus, Michael. *Diversity & Education: A Critical Multicultural Approach.* New York, NY: Teachers College Press, 2015

Note: Throughout the book, images without captions are tapestry details.